D1591550

LEGENDARY LOCALS

OF

CHEBOYGAN

MICHIGAN

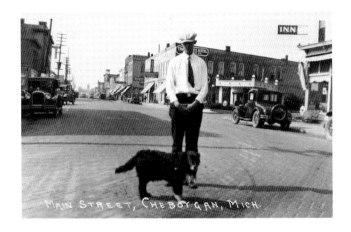

MAIN STREET, CHEBOYGAN, MICH.

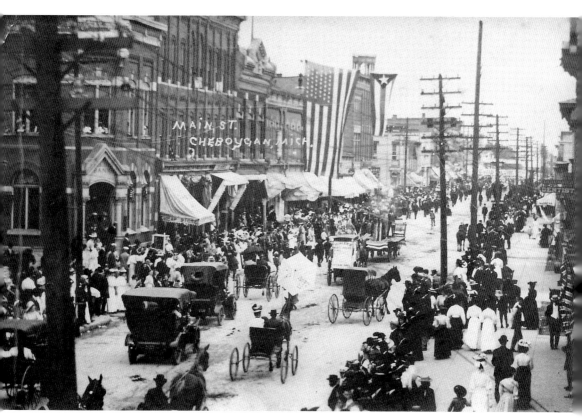

Labor Day, 1908
Locals and visitors alike pack downtown Cheboygan for a Labor Day parade at the corner of Main and Division Streets. (Author's collection.)

Page 1: Welcome to Cheboygan
An unidentified man and his dog pose for a photograph on North Main Street. (Author's collection.)

LEGENDARY LOCALS
OF

CHEBOYGAN

MICHIGAN

MATTHEW J. FRIDAY

Copyright © 2015 by Matthew J. Friday
ISBN 978-1-4671-0161-5

Legendary Locals is an imprint of Arcadia Publishing
Charleston, South Carolina

Printed in the United States of America

Library of Congress Control Number: 2014931535

For all general information, please contact Arcadia Publishing:
Telephone 843-853-2070
Fax 843-853-0044
E-mail sales@arcadiapublishing.com
For customer service and orders:
Toll-Free 1-888-313-2665

Visit us on the Internet at www.arcadiapublishing.com

Dedication
Ad maiorem Dei gloriam inque hominum salutem.

On the Front Cover: Clockwise from top left:
Dr. Walter Larson, physician (courtesy of the Historical Society of Cheboygan County; see page 86),
Jerry Pond, photographer (author's collection; see page 109), Mike Glenn, businessman (courtesy of
Jerry Pond; see page 92), Henry C. Friday, banker (author's collection; see page 73), Harold Ireland,
businessman (courtesy of Jerry Pond; see page 87), Al "Bunk" Bonsecours, fireman (courtesy of the Historical
Society of Cheboygan County; see page 100), Joanna Neale, attorney (courtesy of the Historical Society
of Cheboygan County; see page 114), Jacob J. Post, businessman, (courtesy of the Historical Society of
Cheboygan County; see page 35), Joyce and Quincy Leslie (courtesy of Joyce Leslie; see page 101)

On the Back cover: From left to right:
Embury-Martin logging crew (author's collection; see page 21), Jack Coon (courtesy of Jack Coon; see
page 106).

CONTENTS

ACKNOWLEDGMENTS

Writing a book about people is a truly humbling experience. Diving into the stories of scores of local residents past and present has put Cheboygan into a different perspective for me, and I sincerely hope that by perusing the pages of this book the reader sees Cheboygan in a new light. Learning about events and looking at photographs of buildings is one thing, but to know the stories behind the individuals involved makes the discipline of history much more personal and meaningful.

Naturally, a book about people means that many individuals have assisted me in this project. I would like to thank Jerry Pond, Doug Dailey, Olds Schupp, and the many others who have contributed photographs out of their collections for inclusion in this work. The Cheboygan County History Center and the Cheboygan Area Public Library have also been a great help. The staff at the Clarke Historical Library at Central Michigan University has also been, as usual, very accommodating. My family and friends also deserve a tip of the hat for their patience while I have been working on this book and admittedly absent from visits and social engagements. And a special thanks to you, the reader, for wanting to know a little bit more about the people of Cheboygan.

My biggest regret with this work is that I could not include every single person who fits the description of a "legendary local." I endeavored to include an appropriate cross section of individuals from different walks of life and varied accomplishments. There are many more people who deserve to be in this book, and should be, but with limited space it is simply not possible to include each one. In some cases, photographs could not be located or information was sparse, which partially influenced who was included and who was not. Any omissions or inaccuracies in this work are exclusively my own.

It has been a challenge to put this book together, but it is my sincere hope that it is a fitting tribute to those who have made Cheboygan a better place to live. That has been my goal since I started this project, and I can only hope that I have been successful.

INTRODUCTION

There are few things better in life than the feeling of being surrounded by close family and good friends. A place becomes home not when it is simply a place to hang your hat at the end of the day, but a place where you feel welcome, comfortable, and contented. But a building cannot provide those feelings—only people can. Living in a community that is filled with good people can make even the toughest of days less of a burden to bear, knowing that you are surrounded by people who truly care about you, even if you do not even know them. Cheboygan is just such a place.

From its start as a lumbering community in 1844, Cheboygan has attracted and given rise to a wide variety of people. Early in its history it resembled the towns of the Wild West, with dirt streets, wooden sidewalks, and young men in search of work. The work they did find was often in the area's vast expanses of white pine, with the men as rough as the bark on the trees they felled. When they came back into town with their hard-earned wages, they refreshed their spirits at local watering holes and worked out their differences with weather-beaten fists.

Of course these romantic visions, though accurate, were the exception rather than the rule. While Cheboygan was full of men who worked in the woods and the lumber mills, there were thousands of others who also came to the area. People came from New England, Canada, Poland, and Sweden. They came as doctors, butchers, and undertakers. They came as bankers, teachers, and shopkeepers, people like Dr. A.M. Gerow, Cheboygan's first physician, and Harriet McLeod, the first teacher. In the countryside, farmers settled the land and turned empty pastures and forests into flourishing farms. They came by boat, by rail, and by stagecoach. As the community grew, so too did demand for countless other products and services, bringing people from throughout the expanding United States to the relatively isolated tip of Northern Michigan's lower peninsula.

Cheboygan became a boom town in light of the nation's insatiable appetite for lumber. Lumber barons like Thompson Smith and Millard D. Olds made the equivalent of millions of dollars via the woods, shipping their lumber across the Great Lakes and into the country's growing cities. And Cheboygan went along for the ride, growing just like the rest of the nation.

As the lumber began to run out at the beginning of the 20th century, many people ran out as well. Population rapidly declined, but those who stayed were determined to make a name for themselves in whatever way they could. But it was not about notoriety—it was about living. It was quality of life over money in the bank. While the booming automobile industry lured many away from the region, many also stayed because they did not want to become just another cog in the American industrial machine. They valued a tight-knit community, hard work, and perseverance. These are traits that are still palpable here.

The new century meant a new time for Cheboygan. With more people able to drive their personal automobiles, the area became especially noted as a vacation destination. While resorting in the area had been popular almost from the community's earliest days, the pursuit of pleasure and relaxation became an industry unto itself. Nearly everyone benefited from these out-of-town dollars flowing into the area.

During the dark days of the Great Depression, things grew particularly bleak. Tourism dollars faded, and manufacturing was producing little. By the mid-1930s, however, things were looking better. The shuttered paper mill reopened in 1936, and with the onset of World War II a few years later, more industry returned. The war itself produced locals of special note, men like Ed Stempky and Jim Muschell.

Since the war, Cheboygan has remained a mixed economy of professional, manufacturing, and service sector jobs. Tourism boomed after the war and continues to provide a substantial number of jobs for

the area's residents. Industry became more important in the 1950s, when Procter and Gamble took over the paper plant and employed hundreds of workers. Medical and educational fields were the bread and butter for many more, with women like Doris Reid leaving a lasting impression on the community. The arrival of the first box store in the 1970s was a harbinger of things to come, but Cheboygan, just like every other place, was changing with the times. Today, the area is as varied as ever when it comes to employment, but for so many people, it is not a matter of where they work, but rather where they live.

The people who live here are the ones who truly give this community its flavor. Cheboygan is a place that has seen more than its fair share of trials and tribulations, yet it perseveres—a strong testament, perhaps, to the indelible mark its history has made on its people.

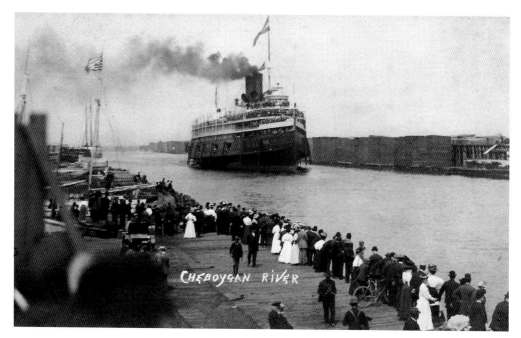

Detroit and Cleveland Steamer Arriving at Cheboygan
Steamers such as the one seen here were used both for pleasurable excursions and bringing new immigrants to Cheboygan. Scenes like this were once relatively common. Tourists and immigrants alike frequently found their way to these docks, and in so doing, contributed to the history and ethnic identity of the region. (Author's collection.)

CHAPTER ONE

Forging the Future

While Native Americans had lived in the area that would become Cheboygan for centuries, for the first European American settlers, the land was little more than a blank sheet upon which to write a new story. Capt. Samuel Robertson had a small dwelling at the mouth of the Cheboygan River in 1778–1779, but his brief appearance was not the true beginning of modern settlement. Venerable Fredric Baraga also passed through the region ministering to Native Americans, though appearances by other whites were relatively rare.

In 1844, Alexander McLeod and Jacob Sammons set the modern epoch into motion when they came here and built a small, water-powered, upright sawmill. Sammons built a home the next year and platted a village, giving away small parcels of land to entice others to come. When early settlers like Moses Wiggins Horne arrived, they found very few comforts of the civilized world and were very much on the fringes of modern society.

But within relatively short order, more and more pioneers arrived and brought with them all the trappings of modernity. The unexpected death of lumber baron Jeremiah Duncan put a temporary hold on progress, and the nation as a whole was dealing with the unspeakable horrors of the Civil War. But by the early 1870s, Cheboygan was on the cusp of becoming a boom town. Property, and the timber that was on it, was in high demand. Francis Sammons helped to make the Inland Waterway navigable, opening up that watercourse to the transport of logs. Men like Thompson Smith built huge lumber mills, and Dr. A.M. Gerow built up his medical profession.

Those earliest settlers were taking a risk. Cheboygan and her sister village at Duncan City were new communities, difficult to get to in the winter, and without any sort of infrastructure. To be successful as a community or in business, a great deal of ingenuity, dedication, and self sacrifice was required. The early pioneers brought that—and more.

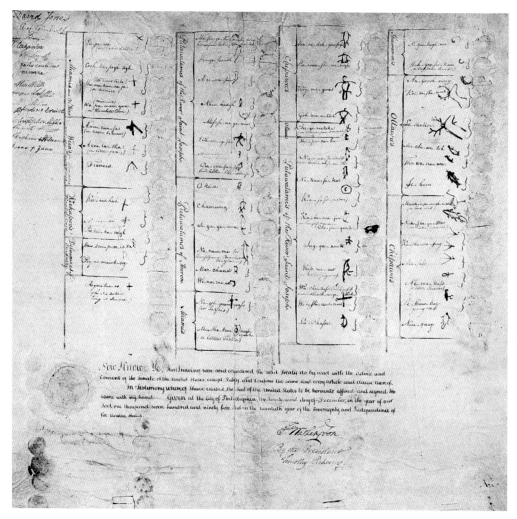

Matchekewis

During the Pontiac Rebellion of 1763, Ojibwe (Chippewa) tribal leader Matchekewis (also known as Mash-ipi-nash-i-wish, or Bad Bird) led the charge to capture the British Fort Michilimackinac at what is today Mackinaw City. During a game of baggatiway, Matchekewis and his Native American companions threw the ball over the stockade of the fort. When the door was opened to retrieve it, the attackers moved in, using weapons concealed by the female spectators. Matchekewis and his men captured the fort, killing 16 soldiers in the process. Eventually, he would be imprisoned, released, and change his allegiance to support the British, fighting for the Crown during the Revolutionary War. Matchekewis was a signatory to the 1795 Treaty of Greenville (pictured) which, among other territories, ceded the Straits of Mackinac region to the fledgling United States. His home was just 15 miles away, at the site of what would become Cheboygan. (Courtesy of the National Archives.)

Northern Michigan Native Americans

Long before the Europeans arrived, Native Americans had established a presence in Northern Michigan. The first native peoples arrived about 8000 BCE and engaged in fishing, farming, hunting, trade, and the manufacture of maple syrup. In 1634, Jean Nicolet became the first European to pass through the region, and soon thereafter, France established posts in the area as well. Later occupied by the British, these posts ushered in an era of trade as Ojibwe and Ottawa peoples gradually abandoned their more traditional ways of life in favor of trading with the Europeans. Numerous archeological sites have been found throughout the area, particularly at the intersection of waterways. The site that would become Cheboygan was one such place, home to a sizeable burial ground that was later used by the community's first white settlers as well. Those graves were relocated to Pine Hill Cemetery (left). (Both, author's collection.)

11

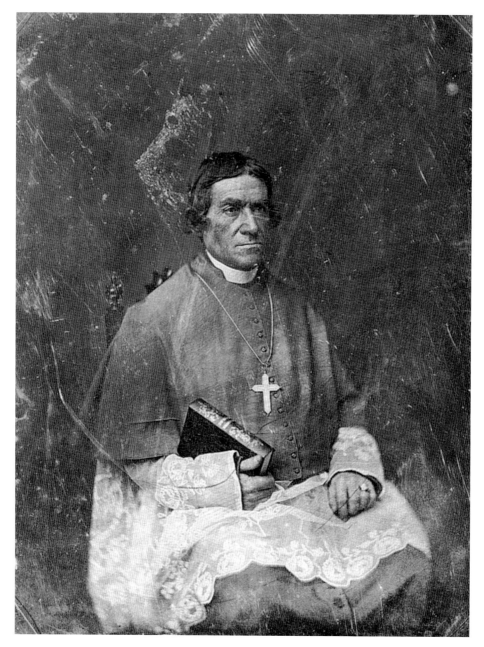

Venerable Bishop Fredric Baraga

Bishop Fredric Baraga, known as the "snowshoe priest" and "missionary to the Chippewa," was a priest of the Diocese of Grand Rapids who catered primarily to the spiritual needs of the Native American population of Northern Michigan. Born in 1797 to a wealthy family in Slovenia, he undertook missionary activities in the remote portions of Northern Michigan and was pivotal in establishing an Indian school at Burt Lake, a short distance from Cheboygan. He was ordained a bishop in 1853 and became the first bishop of the Diocese of Marquette. Baraga left his impact throughout the north by establishing other schools and churches, including St. Mary Parish in Cheboygan. His cause for canonization to sainthood is now pending at the Vatican. (Courtesy of the Library of Congress.)

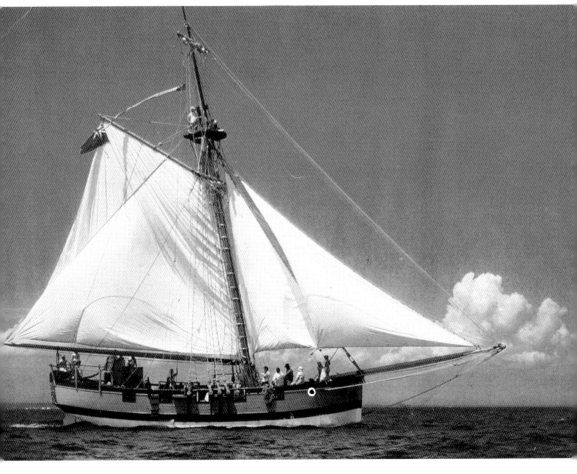

Capt. Samuel Robertson

Stationed at nearby Fort Mackinac on Mackinac Island, Captain Robertson was the first European to spend considerable time at the site that would become Cheboygan. Employed by prominent fur trader John Askin, he spent two winters at the mouth of the Cheboygan River. In 1781, he wrote: "During the Winter, the most safest place near Michilimackinac for winter vessels is the River Shaboygan . . . there is always good Fishing & shooting, there is plenty of fine pines both sides of the River . . . I had a Dwelling House & Garden by the Edge of the wood and the *Welcome* wintered two winters there." Not only did he winter there, but he also traded with the Native Americans in the region while living on the mainland. The original *Welcome* was lost in the Straits of Mackinac in 1781, but a new, historically accurate reconstruction (pictured) was launched in 1981. (Courtesy of Richard A. Wiles.)

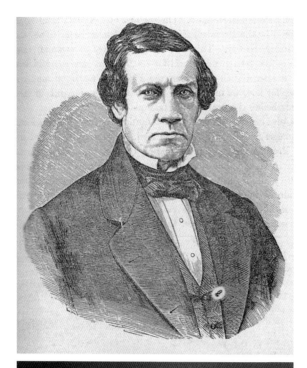

William Austin Burt and John Mullett

(LEFT AND OPPOSITE PAGE)
Some of Cheboygan's earliest pioneers had no idea that they would leave such a lasting impact on the area. William A. Burt (top) was a veteran of the War of 1812, and was elected to the Michigan Territorial Council from 1826 to 1827. Together with John Mullett (bottom), Burt surveyed Northern Michigan and the Upper Peninsula for the federal government from 1840 to 1847. Burt and Mullett were both coworkers and friends, evidenced by the inscription in the book pictured opposite, dated 1842. Burt invented a solar compass that made surveying more accurate, which was particularly useful in surveying the western Upper Peninsula, where large iron deposits rendered regular magnetic compasses useless. This invention would take Burt to the 1851 World's Fair in London. Burt and Mullett Lakes in Cheboygan County are named in their honor. (Top, author's collection; bottom, courtesy of Michigan Masonic Museum and Library; opposite, author's collection.)

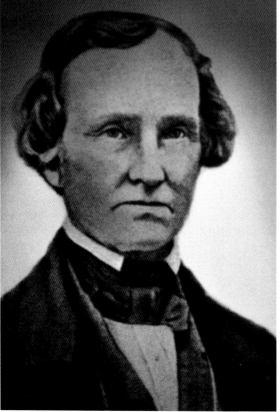

Presented to William A Burt Esqr by his friend John Mullett Detroit Feby 5th 1842.

THE PETER WHITE
PUBLIC LIBRARY,
MARQUETTE, MICH.

John Mullett Detroit M. T.

MATHEMATICAL TABLES;

CONTAINING THE

COMMON, HYPERBOLIC, AND LOGISTIC

LOGARITHMS.

ALSO

SINES, TANGENTS, SECANTS, & VERSED SINES,

BOTH NATURAL AND LOGARITHMIC.

TOGETHER WITH

SEVERAL OTHER TABLES

USEFUL IN

MATHEMATICAL CALCULATIONS.

To which is prefixed,

A Large and Original History of the Discoveries and Writings relating to those Subjects;

WITH THE

COMPLETE DESCRIPTION AND USE OF THE TABLES.

THE THIRD EDITION.

BY CHARLES HUTTON,

LL.D. F.R.S. &c.

AND PROFESSOR OF MATHEMATICS IN THE ROYAL MILITARY ACADEMY, WOOLWICH.

LONDON:

PRINTED FOR G. G. AND J. ROBINSON, AND R. BALDWIN, PATERNOSTER-ROW,

BY E. HEMSTED, FLEET-STREET.

1801.

THE PETER WHITE PUBLIC LIBRARY, MARQUETTE, MICH.

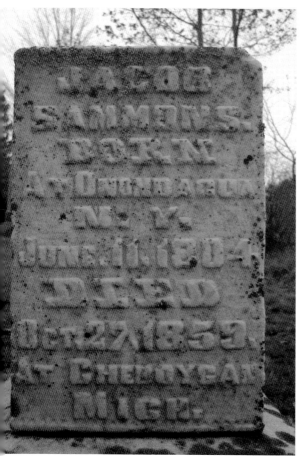
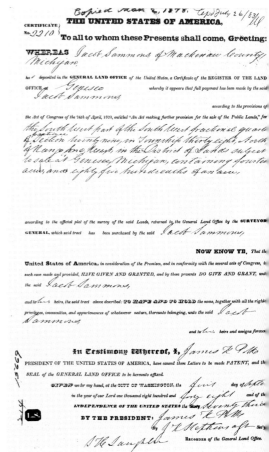

Jacob Sammons

In the fall of 1844, Jacob Sammons came to the Cheboygan River and built a 12-square-foot cabin along its banks. In so doing, he became the first permanent settler in what would become Cheboygan. Sammons worked for Alexander McLeod, a cooper from Mackinac Island, and the pair were the first to take advantage of the area's vast expanses of white pine. While they made barrels for shipping fish from the island, the real force behind Cheboygan's growth would be the timber industry. Sammons was also the original patentee for the land that would become Cheboygan; one of his original patents is picture above, dated September 1, 1848. (Left, author's collection; right, courtesy of the US Bureau of Land Management.)

Old Apple Tree in City Park, Cheboygan, Mich.

Moses W. Horne

Early pioneers in the community that would become Cheboygan had to adjust to an area lacking many basic necessities. One early settler, Moses Wiggins Horne, settled here with his wife, Sarah, about 1849, clearing a piece of land that now encompasses Washington Park. Here they built a house together and planted a variety of fruit trees, including this oft-remembered bent apple tree that stood in the park until the late 1970s. Horne raised animals and had a cooper and blacksmith shop here; as the village grew, he was elected president and appointed marshal and postmaster. His granddaughter remembered him as "a splendid man in his family and a good provider. Always cheerful and generous, looking on the bright side of life." (Above, author's collection; right, courtesy of the Historical Society of Cheboygan County Inc.)

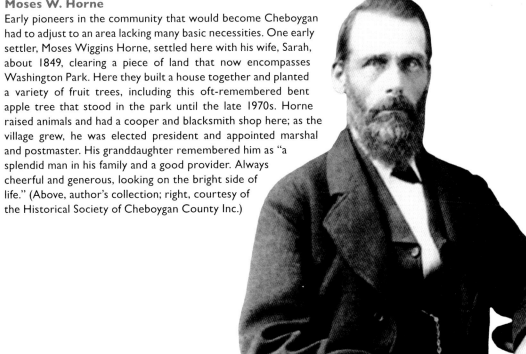

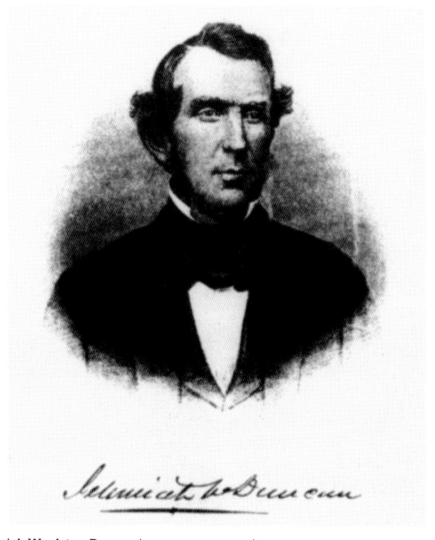

Jeremiah Woolston Duncan (ABOVE AND OPPOSITE PAGE)
Jeremiah Duncan, a native of Delaware, spent little time in Cheboygan. Still, his mark was much more lasting. Duncan was born in 1810 and started his working life as a clerk. He became an important lumber baron in Chicago, and in 1849, bought a lumber mill and property around the bay east of Cheboygan. Duncan made many improvements to the mill and continued to buy more nearby property. A settlement known as Duncan City grew up around the mill. In 1852, Duncan connected this village with the village of Cheboygan, less than a mile away, with a road now known as Duncan Avenue. Duncan City became the county seat of Cheboygan County in 1850, and would remain so until the seat was moved to Cheboygan six years later. Duncan died suddenly in 1854, leading to a period of stagnation in the community that bore his name. Once property issues were rectified some 10 years later, the area boomed until fire destroyed the big sawmill there in 1898. Duncan City was a separate, yet important, part of the corporate limits of Cheboygan. The Duncan City Fire Department is pictured at opposite top in front of the community's store and post office. Later, part of the area was the site of the American Music Camp (opposite bottom), with this structure known locally as the band shell. Today, the entire area is residential, with only two of the original Duncan City homes still standing. (All, author's collection.)

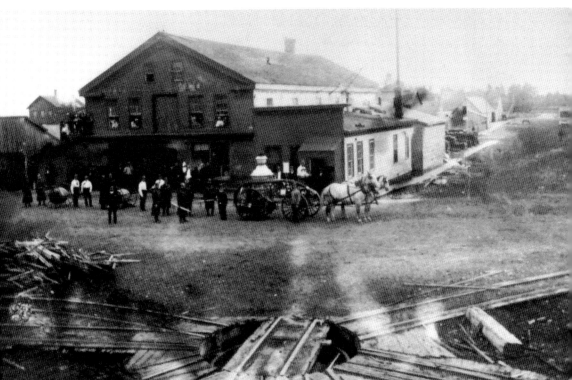

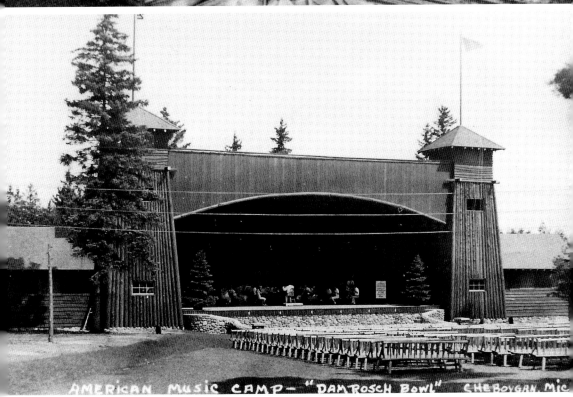

AMERICAN MUSIC CAMP — "DAMROSCH BOWL" CHEBOYGAN, MIC

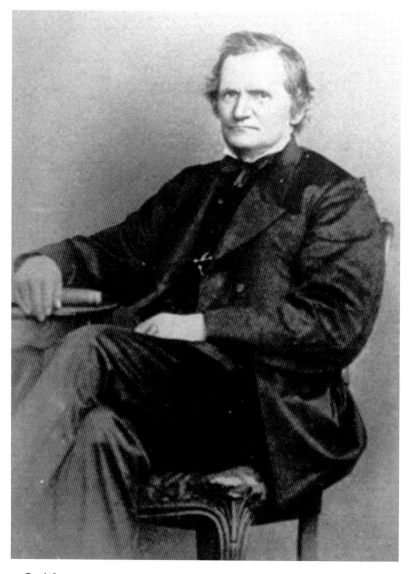

Thompson Smith

After the death of Jeremiah Duncan in 1854, his estate was tied up in court for about 10 years. A series of purchases and buyouts of the property eventually led to Thompson Smith's acquisition of the mill at Duncan Bay and the village surrounding the mill. Under his tutelage, the mill expanded and was the largest lumber mill north of Bay City. A second facility helped process the large amounts of lumber the mill produced. As the owner of all the property in the village, Smith was at the mercy of no one, and had strict rules for the residents of Duncan City. Specifically, alcohol was not allowed, a particularly unusual rule for a community full of young, male workers. Still, he was a generous man, allowing his employees to take wood unfit for market to construct their own homes. After his death in 1884, the Thompson Smith Company was renamed Thompson Smith's Sons. It would remain in operation until fire destroyed the larger of the two mills in 1898. Afterwards, the community of Duncan City was quickly abandoned, with many structures moved from the village across the frozen bay to Cheboygan. The spacious home that once belonged to Thompson Smith is one of only two original buildings that remain at the site today. (Courtesy of the Historical Society of Cheboygan County Inc.)

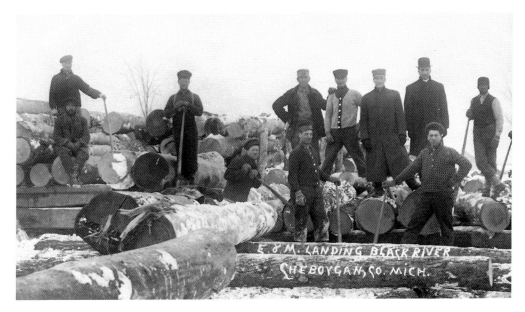

Cheboygan County Lumbermen

Working in the woods as lumbermen was hard, back-breaking, and sometimes deadly work, but it made Cheboygan's settlement possible. In the image above, a crew from the Embury-Martin Lumber Company takes a break to pose for the camera; below, a man from an M.D. Olds crew does the same. There were a variety of jobs in the woods, including felling the trees, cutting off smaller limbs and branches, stacking the wood along bodies of water, rails, or roads, hauling sleighs full of wood, and many more. It was men like these who first came to the Cheboygan area and were responsible for the region's growth and development. As they arrived, they also brought the need for homes, doctors, saloons, hotels, and all other amenities that contribute to making a city. (Above, author's collection; below, courtesy of Olds Schupp.)

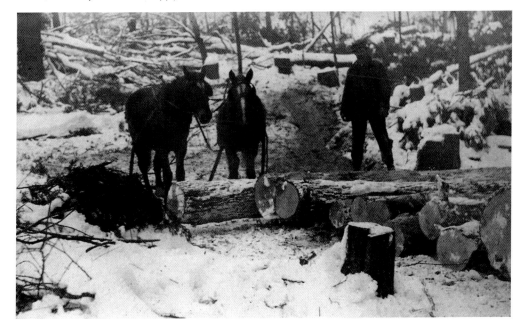

Francis M. Sammons

The son of pioneer Jacob Sammons, Francis helped to further expand the community. He joined his parents here in 1846 and was one of the contractors involved in building the first Third (now State) Street Bridge, instrumental in opening the Inland Waterway to navigation. This bridge meant that the waterway could be used for delivering mail to nearby Petoskey, and it could also be used to move logs between areas where they were felled and the mills. Francis Sammons was county clerk, town supervisor, and Cheboygan's first postmaster. (Author's collection.)

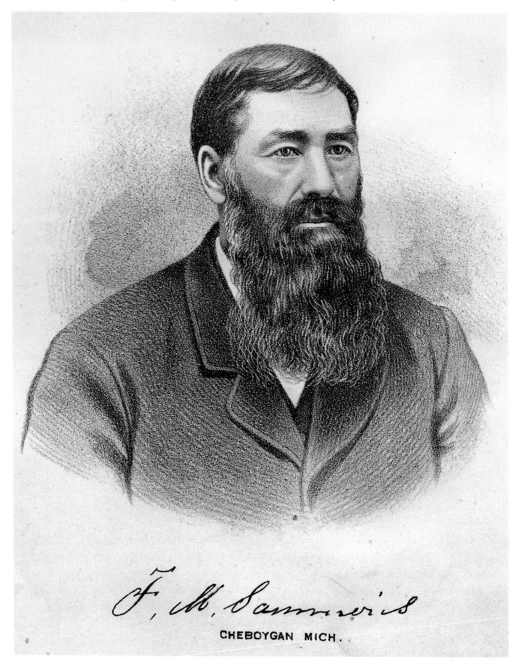

CHEBOYGAN MICH.

Medard Metivier

Among the first permanent residents of the area, Medard Metivier and his wife, Rosalie, settled on land adjacent to Mullett Lake in 1851, but moved to the small village of Cheboygan two years later. He built a hotel there, the Cheboygan House, which was the first in the village. After Cheboygan County was organized, Metivier was elected its first sheriff in 1885. He served as clerk and register of deeds from 1872 until 1885. This letter (below) was written in his role as county clerk. Upon his death in 1885, one account stated that, "In his official capacity he was noted for his courtesy and obliging disposition making friends by his kindness . . . Probably no man ever died in Cheboygan county who was more deeply lamented than Medard Metivier." (Top, courtesy of the Historical Society of Cheboygan County Inc.; bottom, author's collection.)

THE
BEST
TONIC

VER OFFERED TO

Debilitated Persons.

DYSPEPTICS

Sufferers from Liver Complaint.

Those having no Appetite.

'hose with Broken down Constitutions

NERVOUS PEOPLE

Children wasting away;

Any with Debilitated Digestive Organs.

MANITAWAUBA

Bitters

HAS NO EQUAL.

Price $1. 00

r Sale at Maiden & Perrin's
Family Drug Store,
Cheboygan. Mich.

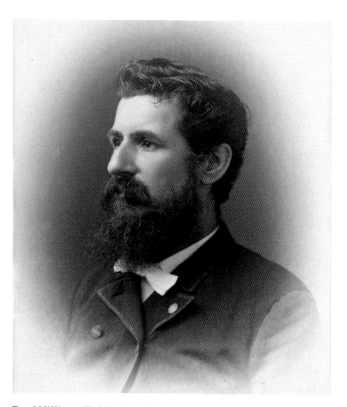

Dr. William P. Maiden (ABOVE, LEFT, AND OPPOSITE PAGE)
Cheboygan has had numerous newspapers throughout its history, but the first was the *Manitawauba Chronicle*, published by Maiden. Originally from Quebec, after his medical training he practiced in New York City before joining the Union Army and serving as an assistant surgeon. After the war, he moved to Alpena, Michigan, and opened a practice there, becoming that community's first permanent physician.

Maiden briefly moved to Cheboygan and opened a drugstore on Third (now State) Street near the bridge. His biweekly paper contained news, local notes and information, witty stories, and advertisements for some of Cheboygan's earliest businesses. Publication began in January 1871 and ended in May of that year with just 13 issues printed. Maiden used the paper to heavily advertise his Manitawauba Bitters, a patent medicine that could be used to cure "dyspepsia (indigestion), jaundice, nervous debility, irregular appetite, languor, drowsiness, wandering pains, headache, lowness of spirits, and all other diseases arising from a disordered liver or stomach."

Apparently, the new physician rose to prominence quickly. Cheboygan was incorporated as a village in 1871, and on May 9, at the first election of officers, Maiden was elected the first village president. He did not stay in Cheboygan for long and soon moved back to Alpena, where he died in 1892. (Above, courtesy of Clarke Historical Library; left and opposite page, author's collection.)

THE
MANITAWAUBA CHRONICLE.

VOL. 1. NO. 3. CHEBOYGAN, MICH., SATURDAY, FEBRUARY, 25th. 1871. PRICE 5 CENTS.

THE
Manitawauba Chronicle

PUBLISHED EVERY OTHER SATURDAY BY

Dr. Wm. P. Maiden.
CHEBOYGAN, MICH.

TERMS $1.00 A YEAR IN ADVANCE.

A limited number of Advertisements will be received at 10 cents per line for each, and every insertion.

BUSINESS DIRECTORY.

W. S. Humphry, Attorney & Councellor at Law.
Office in Legault Block, up stairs.

G. W. Bell, Attorney & Councellor at Law. Notary Public. &c.
Office in Sammons Block, up stairs.

W. P. Maiden M. D., Physician, Surgeon &c.
Office and Store on 3rd Street near the Bridge.

H. W. Horne. Justice of the Peace, Notary Public, &c.
Office in Sammons Block, up stairs.

C. A. Brace & Co., dealers in Dry Goods, Groceries, Provisions, &c. Next door to the Post Office.

A RARE CHANCE
To Invest $5,000

Any good responsible party having the above amount to invest, can hear of a good opportunity to double his money in a short time. Apply to the Editor of the *Chronicle,* Cheboygan

A Strange Mode of Getting a Wife.

The following sketch illustrates the fact, that one little act of politeness will sometimes pave the way to fortune and preferment.

A sailor, roughly garbed, was sauntering through the streets of New Orleans, then in a rather damp condition, from recent rain and the rise of the tide. Turning the corner of a much frequented and narrow street, he observed a young lady standing in perplexity, apparently measuring the depth of the muddy water between her and the opposite pavement, with no very satisfied countenance.

The sailor paused, for he was a great admirer of beauty, and certainly the face that peeped out from under the little straw bonnet, and the auburn curls hanging, glossy and unconfined, over her muslin dress, might tempt a curious or an admiring glance.

Perplexed, the lady put forth one little foot, when the gallant sailor, with characteristic impulsiveness, exclaimed—"That little foot, lady, should not be soiled with the dirt of this street. Wait for a moment, and I will make you a path."

So, springing past her into a carpenter shop opposite, he bargained for a plank which stood in the doorway, and coming back to the smiling girl, who was just coquettish enough to accept the services of the handsome young sailor, he bridged the narrow stream, and she tripped across with a merry "Thank you," and a roughish smile, making her eyes as dazzling as they could be.

Alas! our young sailor was perfectly charmed. What else could make him catch up and shoulder the plank, and follow the little beauty to her home, she twice performing the ceremony of "walking the plank," and each time thanking him with one of her eloquent smiles. Presently, our hero saw the young lady trip up the marble steps of a palace of a house, and disappear within its rosewood entrance; for full a minute he stood looking at the door, and then, with a wonderful big sigh, turned away, disposed of his drawbridge, and wended his path back to the ship, pondering by the way.

The next day he was astonished with an order of promotion from the captain. Poor Jack was speechless with amazement. He had not dreamed of being exalted to the dignity of a second mate's office on board one of the most splendid vessels that sailed out of the port of New Orleans. He knew he was competent, for, instead of spending his money in visiting theatres and bowling-alleys, he had purchased books and had become quite a student; but he expected years to intervene before his ambitious hopes could be realized.

His superior officers seemed to look upon him with considerable leniency, and gave him many a fair opportunity to gather maritime knowledge; and in a year the handsome, gentlemanly young mate, acquired unusual favour in the eyes of the portly commander, Captain Hume, who had first taken the smart little black-eyed fellow, with his tarpaulin and tidy bundle, as his cabin boy.

One night the young man, with all the other officers, were invited to an entertainment at the captain's house. He went, and to his astonishment

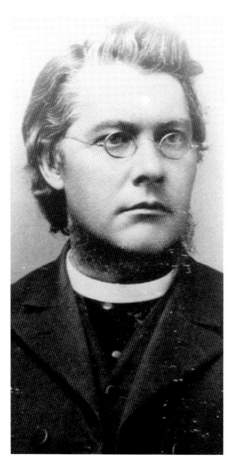

Fr. Peter J. Desmedt (ABOVE AND OPPOSITE PAGE)

The first church in Cheboygan was St. Mary Catholic Church, constructed in 1859. But it was far removed from the center of the rapidly growing village, and soon a new church was needed. The new St. Mary was completed in 1875 under the direction of Fr. Charles L. DeCeuninck (above right, buried with Rev. A.D. J. Piret, who celebrated the first mass in Cheboygan). He was succeeded by Fr. John Van Gennip, who constructed a parochial school in 1881. The school grew quickly, and Desmedt (above left) nearly doubled its size after he followed Van Gennip as pastor. Shortly thereafter, the school was struck by lightning and burned to the ground. Desmedt rallied community support to raise a new one, this time constructed of brick. The new St. Mary (later Bishop Baraga) School stood until 2007 after a new facility was built. (Above right and opposite page, author's collection; above left, courtesy of St. Mary/St. Charles Parish.)

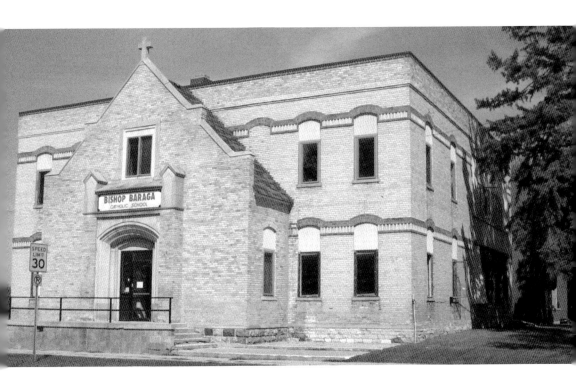

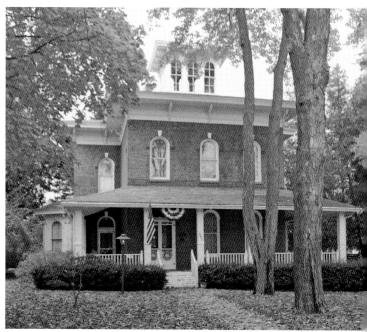

Archibald P. Newton

Newton, together with his brother, purchased St. Helena Island in 1853 and used it as a fuel and supply stop for passing ships in the Straits of Mackinac. Newton was heavily involved in the fishing trade in Cheboygan's early years as well as real estate, dry goods, groceries, and collecting hemlock bark extract for use in tanning leather. He had "a rugged, forceful nature" and was renowned as a cunning and successful businessman. Newton was Cheboygan's second village president, holding that office from 1872 to 1874 and 1876 to 1877. At the time of his death, a local newspaper said that "there was not an old settler from the Soo to Green Bay who did not know him, and few who did not call him friend." Among those few, however, could be counted the Strangite Mormons of Beaver Island.

Newton is a somewhat infamous character in the history of the Straits of Mackinac region. On July 5, 1856, he led a party of about 60 men to Beaver Island to forcibly evict the Strangites located there. Claiming that they had stolen fishing equipment and other goods, the raid forced about 2,600 followers of "King" James Jesse Strang onto steamers and off the island. The raiders then reclaimed what had ostensibly been stolen, including horses, cattle, household goods, fishing equipment, furniture, and more. Strang's house was shot up and ransacked, while some homes and a tabernacle under construction were burned. Strang, who had been shot in an unrelated assassination attempt a few days prior to Newton's arrival, had already left the island. Strang succumbed to his wounds four days after the raid.

In 1871, Newton built the impressive Italianate home pictured above right, the first brick home in Cheboygan, at a cost of $8,500. Still standing today, the home's architectural style is unique in a community where more traditional Victorian-style homes are the norm. Newton died in 1892, but the home has remained in the family of Newton's second wife, Cornelia Allaire, ever since. It is listed in the Michigan and National Registers of Historic Places. (Left, courtesy of the Historical Society of Cheboygan County Inc.; right, courtesy of Andrew Jameson.)

John F. McDonald

McDonald was the namesake of the John F Bridge (above), which has since been replaced twice and is now simply known as the Lincoln Avenue Bridge. The bridge is remembered by residents today as being narrow and somewhat harrowing, owing to the large holes that had appeared in the wooden deck. Adventurous youth would occasionally dive off into the river below.

McDonald came to Cheboygan in the spring of 1865 and was a partner in the purchase of the late Jeremiah Duncan's estate, breathing new life into lumbering in the region and ushering in the lumber boom. After McDonald sold his share of the partnership, he opened a grocery store in an old cooper's shop at the corner of what is now Lincoln and Main Streets. He soon added on to that building (below, right), and its dock on the water was an embarkation point for cruises on the Inland Waterway. Later, this building became the Riverside Sports Shop. (Above, courtesy of Jerry Pond; below, courtesy of the Library of Congress.)

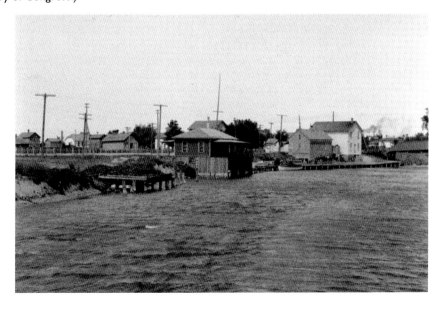

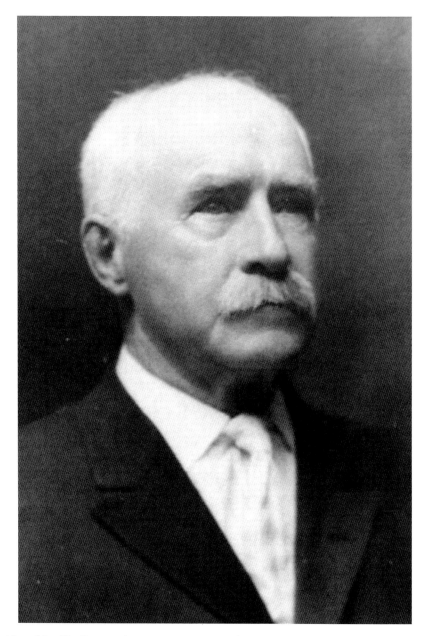

Dr. Arthur Martin Gerow (ABOVE AND OPPOSITE PAGE)
Gerow was one of the first physicians to settle in Cheboygan County. He came to the fledgling community in 1868, armed with only a diploma from medical school and $40. Gerow became a clerk in a local store, saving money when he could, and opened his own drugstore the following year at the corner of Main and Division Streets. He sold that store in 1889 but continued to serve the needs of the community as a doctor. He also owned several large buildings in town (facing page above, right of bank), was responsible for the construction of the Ottawa Hotel (facing page below), served on the school board for 35 years, was pivotal in the establishment of a local library, owned two apple orchards, and was involved in the short-lived Cheboygan Brick and Tile Company. Truly a man of varied interests, Gerow died in 1922 at the age of 75. (All, author's collection.)

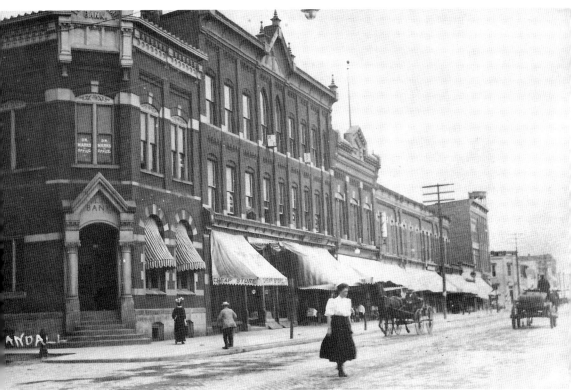

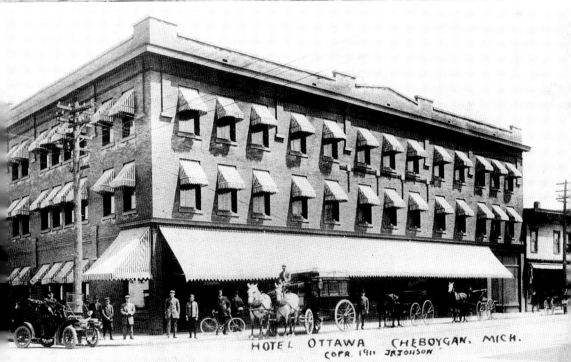

HOTEL OTTAWA CHEBOYGAN, MICH.
COPR. 1911 JR JOHNSON

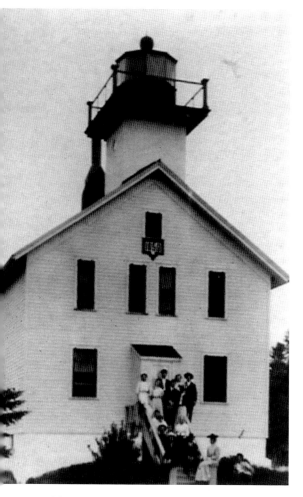 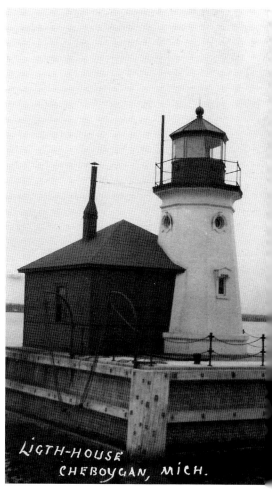

LIGTH-HOUSE
CHEBOYGAN, MICH.

Lighthouse Keepers

With its location on the Straits of Mackinac, Cheboygan needed to have numerous lighthouses in the area to guide navigators away from dangerous shoals and points jutting into the lake and to facilitate easier commerce into and out of the river. The first light in the community was the Cheboygan Main Light, which was built in 1851. That structure was replaced by the one shown above left in 1859. For those in the lighthouse service, such as the family above, duty meant round-the-clock dedication to maintaining the station. The Cheboygan Crib Light (above right) was manned by service members stationed at the Front Range Light just a short distance away. In 1984, the crib light was moved off its crib to the shore and quickly became a symbol of the city. (Both, author's collection.)

CHAPTER TWO

Opportunity Knocking

After Cheboygan's first settlers made their way to the nascent village, those following them recognized that there was potential in this new lumber town. Within just a few generations, new industries were born, fortunes made, and dreams newly realized. For those willing to work, Cheboygan was a place where the industrious and resourceful could turn far-fetched ideas into reality. These included men like Jacob J. Post, a Civil War veteran who opened a hardware store that remained a fixture in Cheboygan until the 1980s. Others came here and opened businesses that were not directly related to the lumber industry but catered to the needs of the community. People such as Charles S. Ramsay with his newspaper and the Moloney brothers and their brewery worked to establish businesses that were required in modern urban life.

But it was not just specific people who helped to give the community its personality. Immigrant groups from Sweden, Ireland, France, Germany, Poland, Quebec, and Ontario all brought their own customs and traditions that are still part of the Cheboygan area today. Many of these ethnic groups had their own churches, schools, and organizations to which they belonged. Families with names like Borowicz, Bur, Jewell, LaHaie, Schley, Socolovitch, Stempky, and Woiderski are omnipresent today and can trace their roots to when immigrant families first came to the region.

Still, Cheboygan was a community that resembled a frontier town in many ways. Although the dirt streets eventually gave way to a more suitable roadbed and brick buildings replaced wooden, the nature of the timberland meant that many workers came through for just a season or two. Not all of these drifters were benign. Till Warner, accused of a horrendous crime, was lynched by unknown Cheboyganites who had no time for the justice system to render its own decision.

Cheboygan experienced growing pains like any other booming town. Hardworking, devoted people answered when opportunity knocked. They built up the community and made it grow while adding to the ethnic, cultural, and historical fabric of the region.

Immigrants to Cheboygan

For the first few generations of Cheboygan's history, it was not uncommon for the mother tongue to be spoken at home while English was spoken outside. Traditions were kept alive, and immigrants kept the faiths and customs from their old homes. Pictured here are the German St. Thomas Evangelical Lutheran Kirche (Church) and the Polish St. Lawrence Catholic Church in Cheboygan. At other places in town, Catholic and Protestant services were offered in French and Swedish, respectively. Today many of the traditions immigrants brought to Cheboygan are still alive and well, from religion to cuisine to celebrations. Many local surnames also reflect the wide range of nationalities that came to the area. (Both, courtesy of Doug Dailey.)

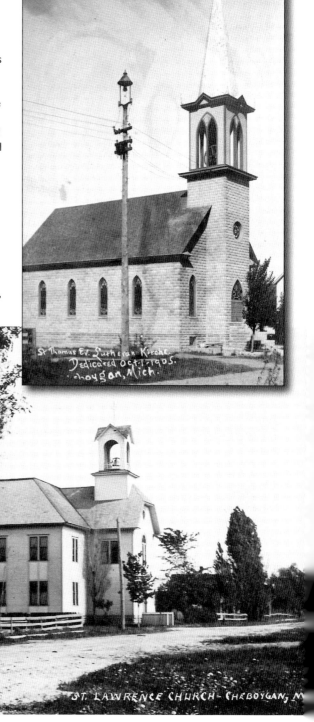

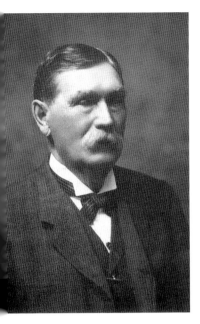

Jacob J. Post.

A true legend of Cheboygan, Jacob J. Post was born in New York in 1839. The eldest of three children, in his youth he learned the value of hard work on the family farm, where he worked until the outbreak of the Civil War. He volunteered with the 136th New York Infantry and was wounded at the Battle of Gettysburg by a bullet to the knee and subsequently discharged. Back at home, he became a clerk and salesman in a hardware store. In 1867, he married Cornelia McArthur, and five years later the couple arrived in Cheboygan. Post opened his own—and Cheboygan's first—hardware store. The business grew over the years, and eventually the building his store was located in became one of the iconic fixtures of Main Street. He had "fine business ability and has always been very attentive to his trade, studying the needs of the community and doing everything in his power to give his patrons the utmost satisfaction in every way . . . and the uniform courtesy and consideration toward the public that has distinguished everybody connected with it." Post was also vice president of the First National Bank from 1882 to 1911, an institution he had helped to create; in 1911, he became president. He also served on the local school board and was active in a fraternal society. When he died in 1912, a local newspaper opined, "The city loses a most valued citizen, one that has been a prime factor in its progress and its upbuilding . . . his influence felt in most of the things that have been best for our city." Another account, written just prior to his death, observed that "no man in Cheboygan County stands higher in the estimation of the people, and none is more worthy of public confidence, regard, and good will." The J.J. Post Hardware Company remained in operation until the 1980s. His beautiful Queen Anne–style house is now a registered Michigan Historic Site. Many of the tools used in the shop, including equipment for pressing tin ceilings, have been preserved by Michigan State University. (Left, courtesy of the Historical Society of Cheboygan County Inc.; right, author's collection.)

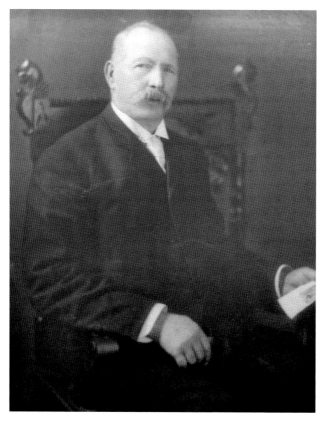

James Moloney

In 1857, James F. Moloney came to the United States from Tipperary, Ireland, at the age of 13. He first settled in Amherstburg, Ontario, and then in Detroit, Michigan. His first job was to spend winters along the Chippewa River farther north, helping to build lumber camps. A few years later, he opened a grocery store in Detroit but, seeing potential in the booming north, relocated to Cheboygan in 1877. Moloney opened a grocery store at the corner of State and Water Streets and bottled drinks in the back of the store. Here he became familiar with and sold various types of beer. His brother William had been a brewer in Detroit since 1876. Following suit, in 1881 James decided to build a brewery.

He purchased a few odd-shaped lots at the terminus of Court Street at Main Street, on the east side of the street along the river. By 1882, James, with his brother and partner Patrick, began work on the newly-purchased lots. The main brewery building was 110 feet long and consisted of seven rooms: two icehouses, a room for the mill and still, an office and engine room, two storage sheds, and a large cellar. In January 1883, the brewery began operation as the Northern Brewery of James F. Moloney & Brother. While still at the brewery, he became the first mayor of the newly incorporated city of Cheboygan in 1889. James eventually left the operation, later known as the Cheboygan Brewing and Malting Company, and went on to other pursuits. He was elected mayor again in 1896 and 1897. He was also a member of the Cheboygan Citizens' Improvement Association, a group of community leaders whose objective was to attract business and tourism to Cheboygan County. Moloney even found time to be an active lodge man in the Knights of Columbus and the Ancient Order of Hibernians, and later became heavily involved in politics and was a delegate to the Democratic National Conventions of 1896, 1900, and 1912. In 1905, he directed the movement to organize the Cheboygan County Savings Bank and became its president. Moloney continued to work at the bank until it was absorbed by its rival, the Cheboygan State Bank, in 1919. After a very full life, he died the following year at the age of 76. (Courtesy of the Historical Society of Cheboygan County Inc.)

Tillott Comstock Warner

In its heyday, during Cheboygan's lumbering era in the late 1800s and early 1900s, the lockup was the focal point for keeping offenders off the streets. While most people who were incarcerated at the old Cheboygan County Jail were housed for common offenses (such as drunk and disorderly conduct or "running a house of ill repute"), there were other, less innocuous offenders housed there. In 1883, Tillot Comstock Warner was hauled from the jail by an angry mob and lynched from a railroad crossing sign just down the street. Warner was being held by the sheriff for the attempted rape and murder of a young girl. The persons responsible for the lynching were never caught. Local newspapers indicated that the leaders of the mob were masked, but more probable is the fact that locals did not want to divulge who was actually to blame. The newspaper, unsympathetically, led with the headline, "The Wages of Sin is Death!" No one else was ever held or tried for the original crime; the little girl, however, made a full recovery. Today the jail that Warner was housed in, and the attached sheriff's residence, is one of the buildings at the Cheboygan County History Center. (Courtesy of the Cheboygan County History Center.)

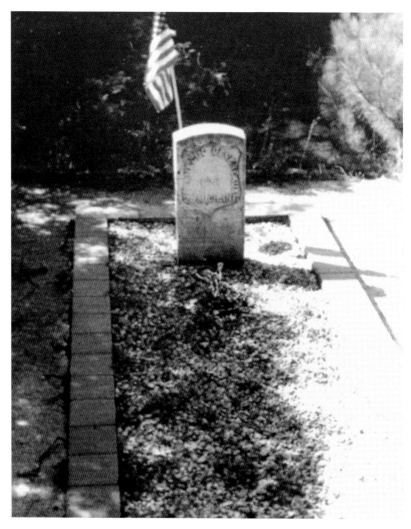

Franklin Devereaux

While the story of man versus wild could be a euphemism for Cheboygan's earliest days, the adage has a particular meaning in the case of Franklin Devereaux. A veteran of the 10th Michigan Cavalry during the Civil War, after his service, Devereaux returned to his Ottawa County home and married a widowed friend. In 1871, Devereaux and his now-pregnant wife were checking beaver traps when a large piece of ice sank their boat, drowning his wife and unborn child, and trapping supplies. Distraught, Devereaux drifted to Cheboygan and worked at a sawmill until he had saved enough money for basic provisions. He then left his job and became a hermit, living in the wild in a crude cabin that was only three feet high.

Devereaux's death, however, is what has made him legendary. In September 1883, an area resident named Samuel Flynn was out gathering blackberries and stumbled across a remarkable scene. A dead man was partially resting on a log, and not far from him was a dead bear. While it can never be ascertained exactly what happened, it seems likely that Devereaux shot the bear through the shoulders and was then attacked, bitten on the arms, shoulders, neck, side, and abdomen. His gun had bite marks on it, and the ramrod was bitten and broken. A violent struggle between man and beast had clearly occurred, and it appears that after Devereaux had killed the bear he went to rest on the log and then succumbed to his injuries. He was buried at the site where he fell (above), and his grave is well maintained by local veterans' groups. Devereaux Lake is named in his honor. (Courtesy of the Aloha Historical Society.)

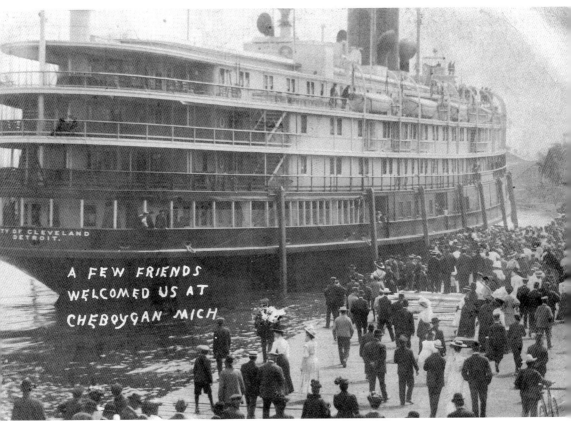

A FEW FRIENDS WELCOMED US AT CHEBOYGAN MICH

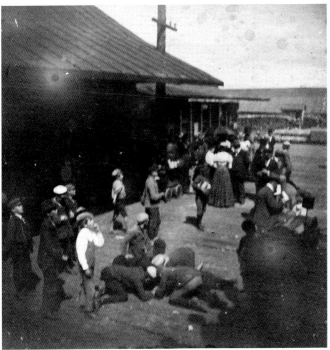

Scrambling for Pennies
Scrambling for pennies at the McArthur Dock was an old tradition in town. As the big passenger steamers pulled up (above), passengers would throw small change from the boat, and children on the dock would make every effort to gather what they could before their friends did, or it fell through the cracks. The rare image at left, from a stereoscope card, depicts the scene. (Both, author's collection.)

1935
K of C Convention
CHEBOYGAN

Fraternal and Secret Organizations (ABOVE AND OPPOSITE PAGE)
Cheboygan has had many different types of fraternal and secret organizations throughout its history. The first was the Free and Accepted Masons Lodge No. 283, chartered in January 1871. Locals joined organizations such as these for camaraderie, service, religion, or any number of other reasons. Some of these groups are still very active today, such as the Knights of Columbus (above), Fraternal Order of Eagles, and Loyal Order of the Moose. Cheboygan has had other organizations as well, including the Independent Order of the Odd Fellows, Ancient Order of Hibernians, Knights of Pythias, Benevolent and Protective Order of Elks (opposite top), Royal Arch Masons (opposite bottom), and many more. Belonging to organizations such as these helped make connections while also enriching a sense of community. (Above, courtesy of the Cheboygan Knights of Columbus; opposite, both author's collection.)

ELKS TEMPLE CHEBOYGAN, MICH.

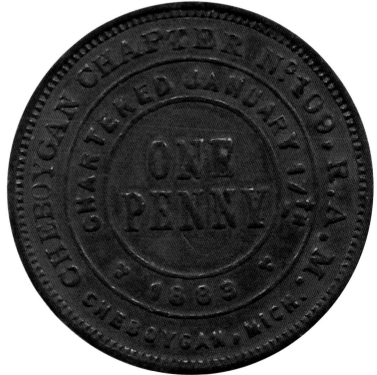

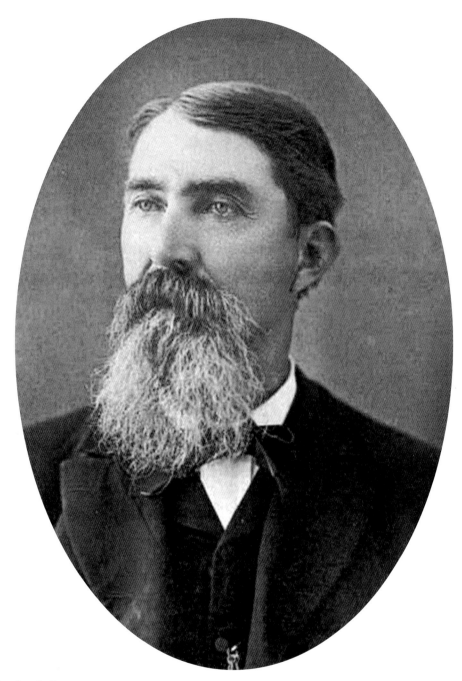

Charles S. Ramsay.
A native of Ohio, when the Civil War broke out in 1861, Ramsay enlisted in the 44th Ohio Volunteer Infantry as a member of the band attached to it. He was discharged in 1862 when regimental and other bands attached to the Army were eliminated. He moved to Cheboygan in 1871, and when the community's longest standing newspaper, the *Northern Tribune*, began publication in 1875, he joined the staff as a reporter. A decade later, he owned the paper, which became the *Cheboygan Tribune* and then the *Cheboygan Daily Tribune*. (Courtesy of the Historical Society of Cheboygan County Inc.)

Sheriff Fred R. Ming, Veterinarian.
Few characters in Cheboygan's past can claim the level of notoriety, or controversy, that Dr. Fred R. Ming can. He came to Cheboygan in July 1880 and worked in a sawmill while studying at night to become a teacher. He furthered his education and earned a doctor of veterinary science degree, after which he served Cheboygan and the surrounding area in his new profession. He soon entered politics as well and served as fire chief, police chief, sheriff, and as a member of the school board. In 1904, he was elected to the Michigan House of Representatives, and in 1906 he moved to the State Senate, where he served two terms. After his tenure in the Senate, he went on to serve in the House once again, from 1929 to 1932. While serving as Speaker of the House, Ming introduced a bill to the legislature for the construction of a sanitarium for those afflicted with tuberculosis, an affliction that caused the deaths of three of his brothers. The legislation passed, and the new facility was constructed in 1937.

While Ming was certainly a devoted public servant, his legacy will always be shrouded in controversy. In the 1890s, lumber speculator John McGinn purchased land for back taxes that was inhabited by Native Americans. The small village of Indianville located there was home to about 21 families. These people had put their specially-reserved land in trust to the governor when obliged to take individual tracts. They then paid taxes on the land for some time, but either through malice or otherwise, received bad advice that they did not have to do so. The result was that their land went up for tax sale and was purchased by McGinn. He then warned the Native Americans to get off the land that he now owned. When all but two refused to do so, he solicited the help of Sheriff Ming. On October 15, 1900, Ming and his deputies removed personal possessions from the remaining 19 cabins at Indianville, doused the homes with kerosene, and set them ablaze. Though apparently within the law, this action brought about immediate calls for relief for the affected people, including from Gov. Hazen Pingree. To this day, the events surrounding the burning of Indianville remain highly controversial and hotly debated. (Courtesy of the Historical Society of Cheboygan County Inc.)

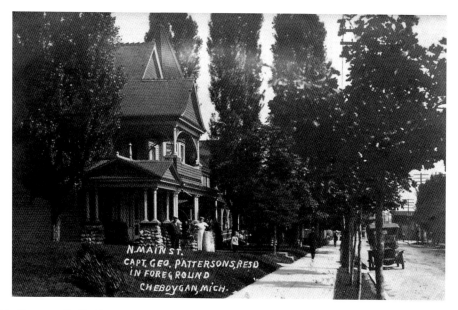

Capt. George E. Patterson

Patterson was a man of varied interests. He and his wife, Estella, owned a farm in Indian River at the junction of the Indian and Little Sturgeon Rivers. The farm was equipped with a flowing well that piped water to house and barn, a rarity at the time. Patterson also owned a tugboat, the *George E.*, that he used to tow logs for lumbermen on the area lakes and rivers. Later he became the vice president of the Embury-Martin Lumber Company, the last of the major lumber mills to operate in Cheboygan. He is pictured above standing in front of his home on Main Street in Cheboygan. Across the street was Patterson's Pavilion (below), a popular area for gathering throughout the year. It was equipped with an electric light that could be turned on from inside the house just in case two lovebirds got a little too frisky. (Above, courtesy of Olds Schupp; below, courtesy of Ed Kwiatkowski.)

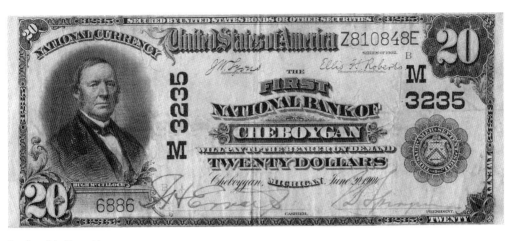

Irving H. Erratt

Irving H. Erratt was well known in Cheboygan banking services and had a long career with the First National Bank of Cheboygan. After finishing school, he worked at the bank for almost his entire professional career. An involved and well connected citizen occupied "with everything advanced for the community and city advancement," Erratt was a city alderman, manager of the Cheboygan Opera House, fire chief, and a member of the Elks, Rotary (president), and Masonic organizations. His signature is seen above on a banknote and below on letterhead issued by the First National Bank of Cheboygan. (Both, author's collection.)

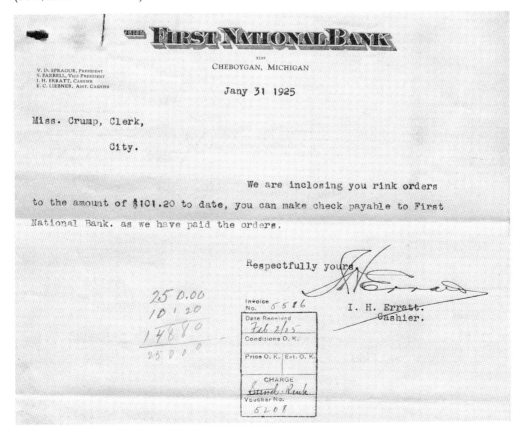

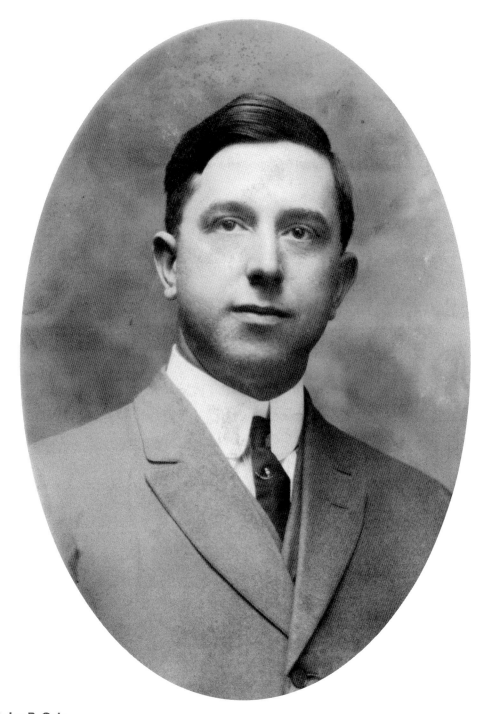

John P. Och.
Born in New York City, John P. Och came here as a traveling shoe salesman. A widower, while traveling to Cheboygan he met a young widow named Sarah Dickson, whom he later married. After managing a general store on Duncan Avenue with his wife, he would later go on to open his own shoe store next to the Kingston Theatre. (Courtesy of the Historical Society of Cheboygan County Inc.)

Victor D. Sprague.
A prominent local attorney and judge, Sprague developed a large practice in Cheboygan. At the outbreak of World War I, he entered the Army as a major judge advocate and was eventually assigned to the Army War College. After the war, he became a prosecutor and city attorney, later a circuit court judge. He was also treasurer of the Embury-Martin Lumber Company, Rotary Club president, and president of the First National Bank of Cheboygan. (Author's collection.)

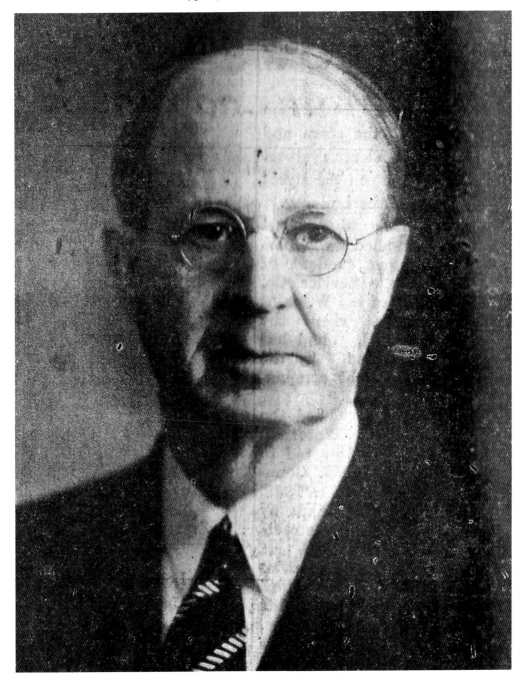

Millard David Olds (ABOVE, LEFT, AND OPPOSITE PAGE)

Perhaps no Cheboygan County lumber baron is as well known as Olds. He was born to a family of modest means in 1860. Starting his working career in Cheboygan in a stave mill, he worked his way up and through resourcefulness and ingenuity became the owner of one of the most successful lumber mills in Cheboygan. Olds went into business when many local lumber mills were closing up, but he was able to make extra money by being frugal and even selling waste products to the local paper mill for fuel. His home, seen opposite below, was for many years a landmark in Cheboygan. Olds's mill closed in 1916, but afterwards he continued his business ventures by selling coal. When Olds died in 1935, it was the end of the era of lumbering in Cheboygan. (All, courtesy of Olds Schupp.)

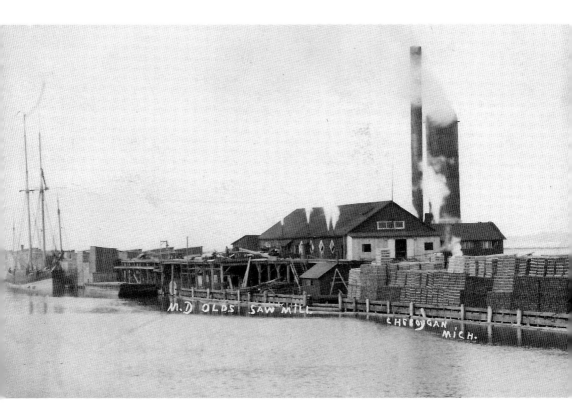

M.D. OLDS SAW MILL CHEBOYGAN MICH.

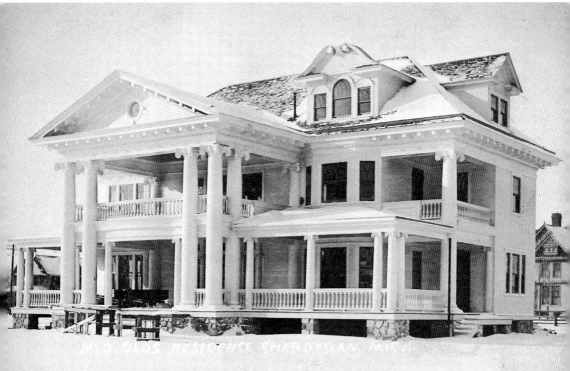

M.D. OLDS RESIDENCE CHEBOYGAN MICH.

William F. DePuy

Cheboygan has had its fair share of unique and largely forgotten businesses over the years, and certainly among them was the Cheboygan Pea Canning Company. The jovial and lighthearted DePuy was the secretary and treasurer of the organization and also served as a city alderman. Along with G.D.V. Rollo, he founded the first bank in Cheboygan, Rollo, DePuy, and Co., in 1875. The Pea Canning Company only operated for about 15 years and had different owners in that period. Land was leased from local farmers who grew the peas and were then paid for them at harvest time. Later, other products were canned here, including beans and spinach, and the name changed to the Cheboygan Canning Company. (Left, author's collection; below, courtesy of Doug Dailey.)

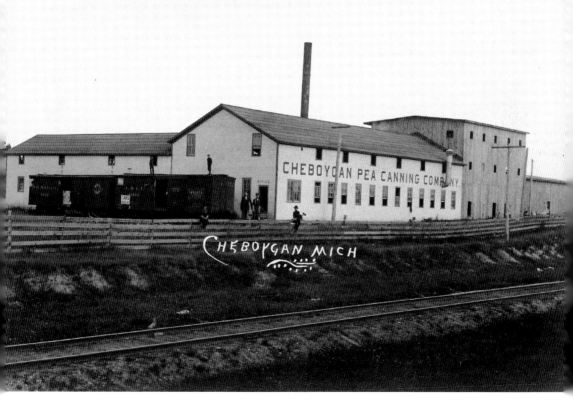

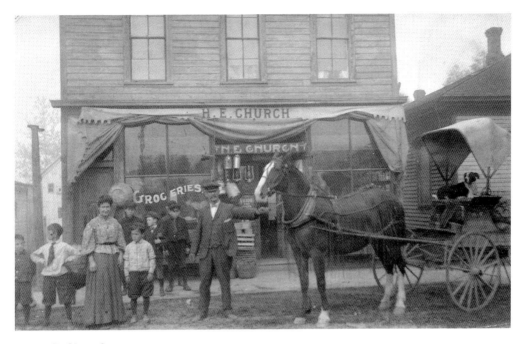

Hugh E. Church

Small grocery stores like the one shown here were once typical sights in any city in America. Church (above center, holding reins) owned a grocery store on Mackinaw Avenue. The well stocked store carried a variety of goods, including Fels-Naptha and Ivory soaps, oleomargarine, oats, gelatin, and plenty of other items as seen below. Here the proprietor poses for a photograph in the store with his wife, Emma. The building is still a grocery store today, albeit in a different incarnation, as Alcock's Market. (Both, author's collection.)

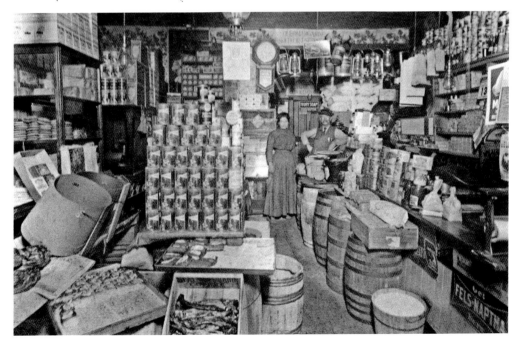

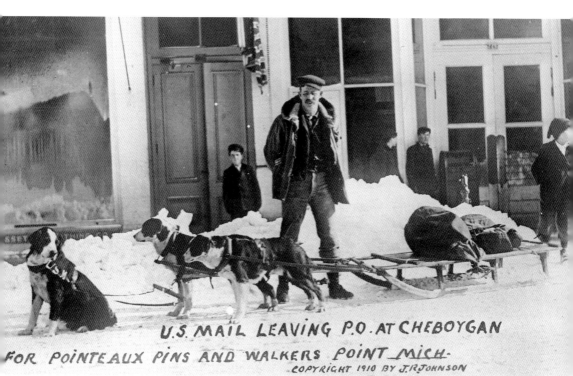

U.S. MAIL LEAVING P.O. AT CHEBOYGAN FOR POINTE AUX PINS AND WALKERS POINT MICH.
COPYRIGHT 1910 BY J.R.JOHNSON

Fred Roberts

Carrying the mail from Cheboygan to Bois Blanc Island in the winter was a dangerous affair. When the ice was sufficiently thick, Fred Roberts (center) had the duty of delivering the mail across the frozen expanse either by horse or dogsled. It was a dangerous job—on one trip in February 1914 he went through the ice three times returning to Cheboygan but was pulled from the water by his assistant. Later that year, Roberts and another assistant named Joseph White were making the same journey, and the ice broke up about two miles offshore. The ice they were on came ashore about 18 miles from Cheboygan. Roberts survived the ordeal, but White had succumbed to the elements. (Author's collection.)

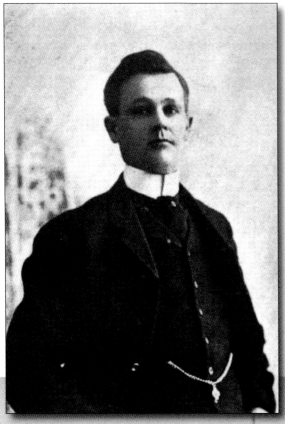

Daniel J. McDonald
The son of two of Cheboygan's earliest pioneers, McDonald made history himself by being one of the organizers and a charter member of Company H (later renamed Company K), 3rd Infantry of the Michigan National Guard, located in Cheboygan. He and his fellow soldiers saw action in Cuba during the Spanish-American war. Afterwards, he was a manager for the W. and A. McArthur Company before venturing out on his own and establishing the Hub Mercantile Company. He was also instrumental in the construction of a new armory in Cheboygan, which later became the Thompson Gym. (Left, author's collection; below, courtesy of Doug Dailey.)

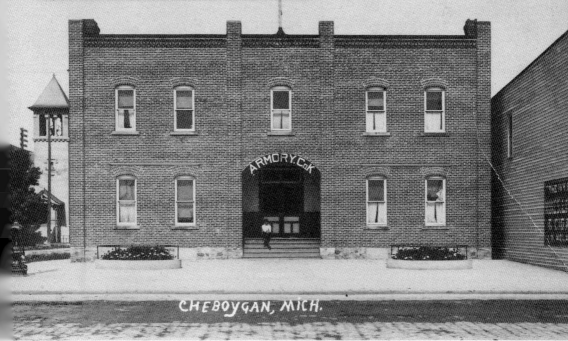

Lt. Col. William S. McArthur
Cheboygan's National Guard unit was dispatched to fight in the Spanish-American War, where McArthur was captain of Company H, 33rd Regiment, Michigan Volunteer Infantry. Here they fired the first shots at the Battle of San Juan Hill on July 1, 1898, and remained under heavy fire for several hours. McArthur was later promoted to lieutenant colonel. During World War I, Company K (formerly Company H) was deployed to France, fighting in the Aisne-Marne, Oise-Aisne, and Meuse-Argonne Offensives. They were part of the Army of Occupation and returned home in April 1919. Company K was disbanded after the war, but the Michigan Army National Guard was reorganized in Cheboygan some years later. Today it is the 46th Military Police Company. (Author's collection.)

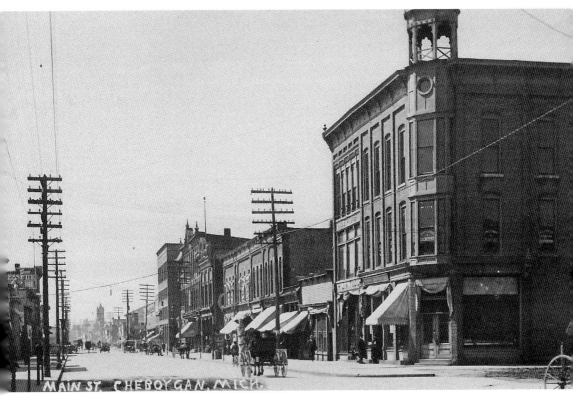

Henry "Hank" J.A. Todd

A clever businessman from an early age, Todd was a bit of an eccentric whose presence was always welcome wherever he was. Born on Mackinac Island on October 10, 1851, he moved around with his parents for a time before finally settling for good in Cheboygan. By the time he was 15, he had set up a fruit stand at the site where the Ottawa Hotel used to be, at the northeast corner of Main and State. Later, in 1880, he constructed a building there and sold ice cream and confectioneries. A bakery was added soon after, the Peerless Bakery. Early in life, Todd also had an interest in a sailing vessel and sailed for two seasons. Later, Todd constructed an impressive brick building (at right) at the southwest corner of Main and Backus Streets. From here he operated a store selling all kinds of items, from confectioneries and toys to stationery and souvenirs. He would stand outside his store and greet all the passersby. Many souvenir plates and toothpick holders that bear Cheboygan's image also bears Todd's name on the back.

Always active locally, Todd was elected mayor in 1901–1902, and for a time he was manager of the Opera House. He was also active in the Knights of Pythias. Todd married in 1875, and he and his wife, Marie, had three children. Only a daughter survived until adulthood; one son died in infancy, and another drowned in the Straits when he was 17. As the body was never found, Todd always kept up hope that one day his son would be found alive.

Todd is remembered as being an exceedingly gentle and kind man. His signature silk top hat was a personal trademark. One description of his personality ran thus: "It is said of him that he knew everybody in Cheboygan and vicinity. He was a congenial sort. If he knew everybody, everybody knew him; and his inevitable silk hat and the rattle of silver dollars in his pocket are recollections that keep alive the memory." (Author's collection.)

Vincent Buerger

Buerger established a blacksmithing shop in 1883 at a time when Cheboygan was growing rapidly. His services were greatly needed, as the community was in the middle of a period of unprecedented growth and prosperity. Buerger also did various other metalworking, including horseshoeing and repairing carriages. He also seemed to have embraced the advent of the automobile, as he can be seen in the image below preparing to go out for a drive with some friends. (Left, courtesy of the Historical Society of Cheboygan County Inc.; below, author's collection.)

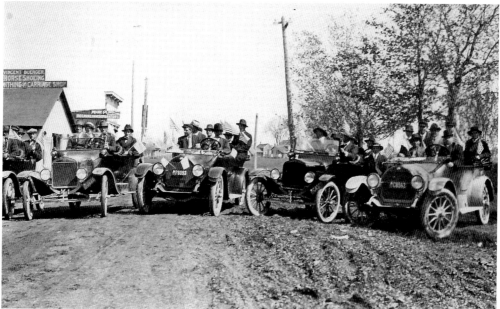

Schwartz Brothers

In 1902, three of the Schwartz brothers (Jack, Charles, and Amiel) formed the Schwartz Brothers and Company Boiler Works, manufacturing boilers, snow rollers (compactors), metal bridges, tanks, fire escapes, smoke stacks, and more. They owned a patent on the Brazel Snowplow, invented in Cheboygan by P.B. Brazel. Over time, the business evolved into not just boilers but also industrial plant maintenance, ship alteration services, welding, sandblasting, painting, and a variety of other tasks. Now in its third generation of family ownership, Schwartz Boiler Works continues to maintain a family tradition of excellence. Pictured here are the original Schwartz Brothers founders, from left to right, (first row) Arthur and Charles; (second row) Jack, Bill, and Amiel. (Courtesy of the Schwartz family.)

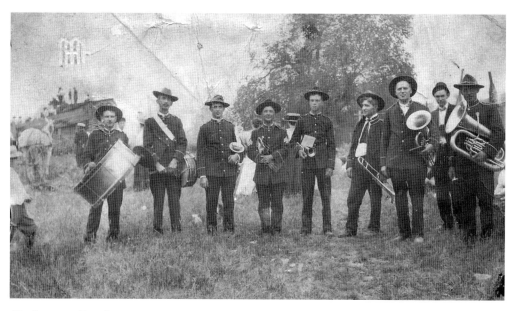

Cheboygan Bands

Cheboygan has had a number of bands throughout the years, including the Municipal Band (above) and Firemen's Band. Bands such as these could be heard playing in parades and festivals and in places such as Washington (City) Park. In the image above, members including Eugene Geyer (bass drum) and P.M. Horn (baritone) pose for a photograph; below, the Firemen's Band poses behind the St. Charles School building. Performances were once very common in these places. While there is no longer a municipal or firemen's band, the current high school bands have won countless accolades year after year. (Both, author's collection.)

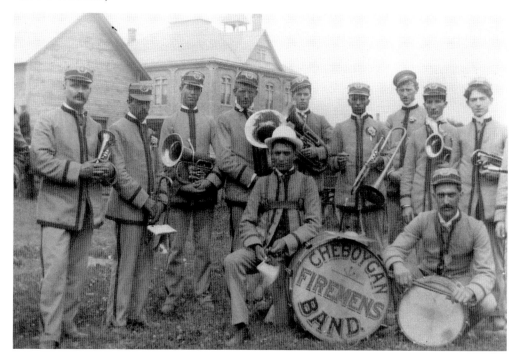

CHAPTER THREE

"The Town that Refused to Die"

After the lumber era ended, Cheboygan was left with a crisis of identity. If lumber had built Cheboygan, then what would it be after the lumber ran out? For many, it mattered little, as they sought employment elsewhere. Cheboygan County's population dropped off dramatically, and the number of manufacturing establishments in the area fell precipitously as well. Men, women, and entire families left town seeking employment in lumber mills in other areas or in the burgeoning auto industry. Times were changing.

There were plenty of people who decided to stick it out and make the best of a situation that appeared very, very bleak. Some, such as John Garrow, changed occupations to better fit the times. Some worked at other industries, including tanning leather at the Pfister and Vogel Tannery. World War II breathed new life into manufacturing, as small, local companies produced goods needed for the war effort. In a July 1946 article in the *Saturday Evening Post*, the author called Cheboygan "the town that refused to die." As the years went on, men like Myrt Riggs did everything they could to boost industry and attract new people to the stubbornly persistent community.

One of those major new industries was tourism. Visitors coming north to experience the natural beauty of the region were nothing new, but it became especially important once the traditional *raison d'être*—timber—was gone. Chuck LaHaie understood this very well, and was responsible for the establishment of multiple national lakeshores throughout Northern Michigan. As people became more mobile with the greater accessibility of the automobile, and as new roads were constructed, tourism became big business. It would take until after World War II before this new tourism potential was realized, at a time when industry finally began to reemerge as well.

The first few decades of the 20th century were anything but easy for Cheboygan. Between depopulation, loss of industry, a massive downtown fire, and the Great Depression, it was a tough time to be a Cheboyganite. The result was a population that shrank but also became incredibly resourceful and resilient. Better times were ahead, thanks to those who had stayed the course and steadfastly resolved to make a living in a community that had clearly seen better days. Their tenacity was not in vain.

Promoting Cheboygan

Today, the Cheboygan Area Chamber of Commerce (above) takes the lead role in area promotion, but it is a later incarnation of organizations such as the Cheboygan Improvement Association and Cheboygan Citizens' Improvement Association. In 1898, the latter published *Cheboygan, Up-to-Date* (below), a marketing booklet that tells a great deal about turn-of-the-century Cheboygan. The chamber was originally organized in 1906, and reorganized in 1920. Since that time, the organization has been touched by many different community leaders and businesspeople, while also serving as a source of information for locals and visitors and encouraging further economic development. (Both, author's collection.)

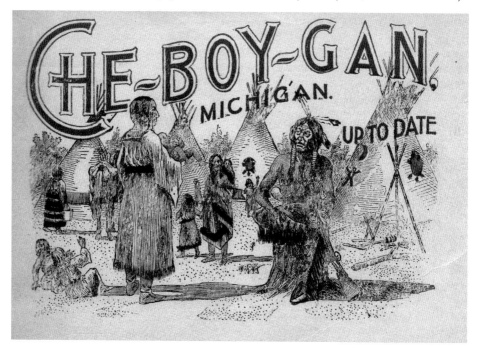

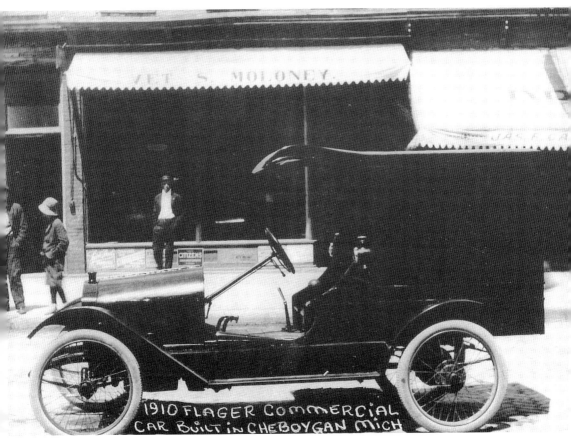

1910 FLAGER COMMERCIAL CAR BUILT IN CHEBOYGAN MICH

Elias Flagler

The automobile industry in Cheboygan was short lived. Flagler left his mark on Cheboygan by making just one automobile, as a means to lure local capital into his venture. The Flagler Cyclecar Company of Cheboygan was organized in 1914, and after locals had invested their hard-earned money in the new company, the proprietors drove away in the one car that had been built. Many lost considerable amounts of money in the fiasco, and it is unlikely that any of it was ever collected later. (Author's collection.)

William Cross
The last surviving Civil War veteran in Cheboygan County, Cross was a dedicated public servant, spending 10 years as county clerk, 12 as probate judge, and 12 as circuit court commissioner. During the war, he was captured by Confederate forces and kept as a prisoner of war at Danville and Libby, Virginia, nearly dying from the conditions and brutality. He died in 1937 at the age of 93. While Cheboygan County was sparsely populated at the outbreak of the war in 1861, many of the area's earliest pioneers were veterans of the Civil War who later relocated to the community. (Author's collection.)

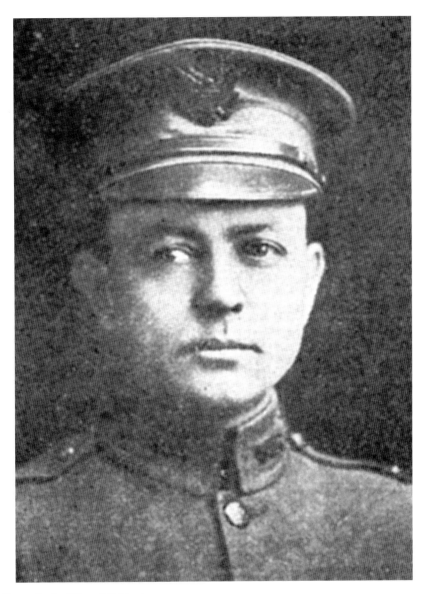

Capt. Francis A. "Frank" Barlow
The namesake of the Cheboygan American Legion Post No. 95, Barlow was employed with the postal service in Cheboygan. In September 1915, he enlisted as World War I raged in Europe. The United States would not enter the war for another two years, but when it did, Barlow found himself in northern France. He was noted among his men as being thoughtful, cheerful, and loyal. While serving with the 125th Regiment, 32nd Division, of the Allied Expeditionary Forces near the Ourcq River, he was placed in command of his company. Although severely wounded "with his back ripped open and blood streaming from his wounds [he] still led his men and refused to retire." These heroic actions earned him a Distinguished Service Cross. On October 7, 1918, he was shot by a sniper at the Battle of Château-Thiery and died instantly. As one who spent almost all of his life in Cheboygan and as a Boy Scout leader, Barlow's death hit the community hard. Yet as the *Cheboygan Democrat* noted, he is remembered as one who "cheerfully sacrificed his life in the cause of humanity," meeting death "with the same hopeful smile with which he bade his friends good-bye." (Courtesy of Sam Fralick.)

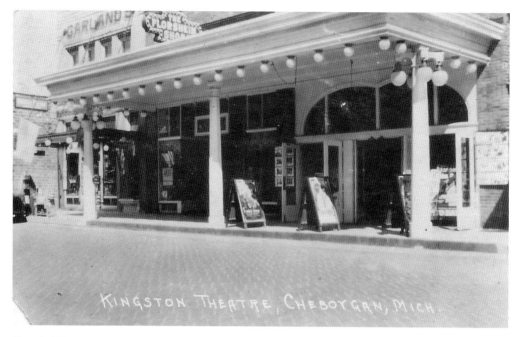

Frank Kingston.
Very little is known about Frank Kingston, but despite his short stay in Cheboygan, his name has remained known to generations. In March 1920, Kingston opened his new Kingston Theatre, a venue suited for the performance of motion pictures and live acts. Upon its opening, the *Cheboygan Democrat* opined, "It was not thought possible that our city would have such a commodious, such a spacious, well-appointed and thoroughly up to date a place as is now theirs." Kingston was not in Cheboygan for long, but the theatre has retained his name throughout the decades and remains today a destination for first-run films. (Both, author's collection.)

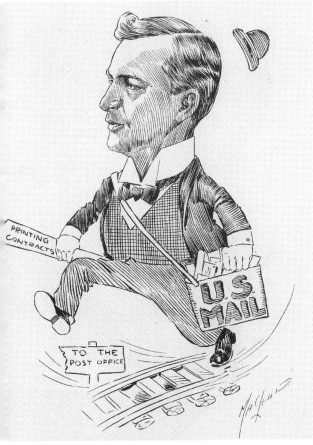

Daniel P. McMullen.
Originally from Ontario, McMullen relocated to Bay City, Michigan, where he learned the printing trade. He moved to Cheboygan in 1881 and managed the *Cheboygan Tribune*. After 15 years there, he opened McMullen Printing Supplies. He was mayor from 1890 to 1893 and in 1898 and 1900 was elected to the Michigan Senate. In 1902, he was appointed postmaster in Cheboygan and served in that capacity for 10 years. (Left, author's collection; below, courtesy of Doug Dailey.)

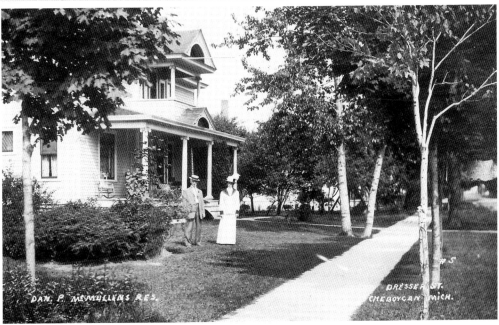

Frank Hohler

Hohler was the proprietor of the F.H. Hohler Bakery, later the White House Bakery. He is shown below with family members and employees in front of his business. From left to right are Ida Hohler, Estella Hohler, Edith Kahlbow, Lillian Hohler, unidentified, Charles C. Morrow, unidentified, Frank Hohler, and Melvin Hohler. Frank was killed on March 8, 1922, while trying to remove equipment from his burning store. The fire took three lives and destroyed four business blocks in town. After the fire, Frank's dachshund was seen rummaging about the rubble, fruitlessly looking for its master. (Right, courtesy of The Historical Society of Cheboygan County Inc.; below, courtesy of Mary Savage.)

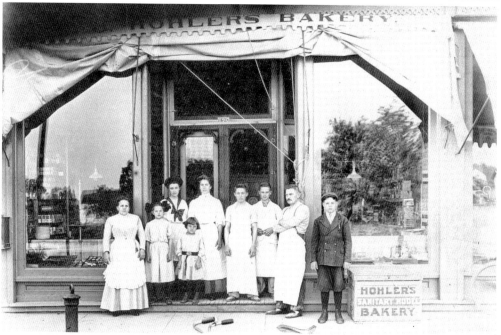

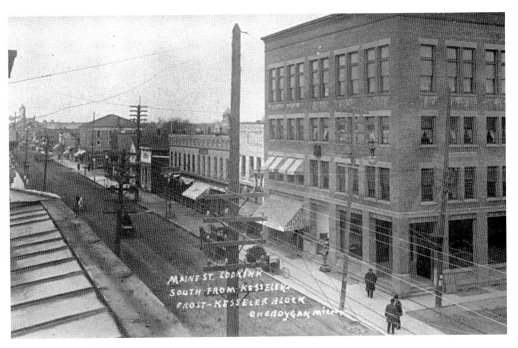

MAINE ST. LOOKING SOUTH FROM KESSELER FROST-KESSELER BLOCK CHEBOYGAN MICH

Charles C. Morrow

On March 8, 1922, a devastating fire ripped through downtown Cheboygan and destroyed some of the largest buildings in town. One of these was the White House Bakery (above, immediately right of center pole), where a 12-year-old Charles Morrow was employed. While owner Frank Hohler and two other teenage employees, George Tobias and Edward J. Laway Jr., tried to move out equipment from the burning building, part of the north wall collapsed, and Hohler and the boys were killed. Morrow, however, hid in the bakery's oven while debris and flames rained down and the family assumed the worst. After the fire was out and the oven cooled down, Morrow emerged, apparently unscathed. He walked home, and upon opening the door to his house he discovered his mother rearranging the furniture for his wake. (Left, courtesy of the Historical Society of Cheboygan County Inc.; above, author's collection.)

67

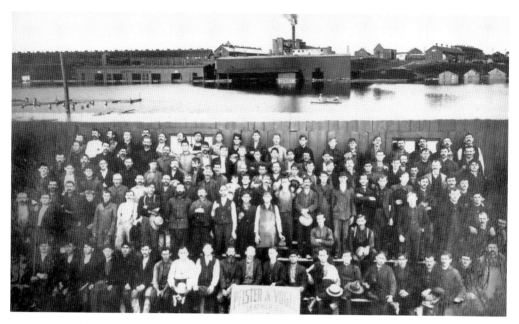

Cheboygan Tannery Workers

While lumbering was always Cheboygan's major industry, other manufacturers brought plenty of jobs to the community as well. The Pfister and Vogel Leather Company, also known as the Tannery, was located just south of town and employed 150 people. The sprawling facility had some 30 buildings, a railroad spur line, apartments, a hospital, a store, a school, and a tavern immediately adjacent. Houses for workers were also located nearby, many of which still stand today. The Tannery opened in 1892, taking advantage of Cheboygan's water transportation network and the area's hemlock trees. Hemlock bark extract was used in the tanning of hides.

Workers at the Tannery enjoyed steadier work than those in the woods or lumber mills, and employment there meant that even as the lumber industry faded, there was still work to be had. The Tannery operated until 1926. (Above, author's collection; below, courtesy of Doug Dailey.)

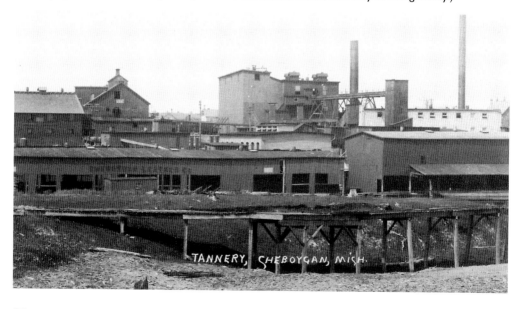

Jessie B. Rittenhouse

Jessie Rittenhouse only lived in Cheboygan for one year, although her family connections ran deep. She was sister to John Rittenhouse, local maker of rustic furniture. She was born in Mount Morris, New York, in 1869, and her later education in journalism was funded by her uncle Archibald MacArthur, a second-generation lumber baron in Cheboygan (Duncan City). Jessie joined the editorial staff of the *New York Times* in 1905, while also corresponding with other poets of the time, including T.S. Elliot and Robert Frost. She married fellow poet Clinton Scollard in 1924, and three years later began teaching at Rollins College in Florida. While living in Florida, she founded the Poetry Society of Florida and sought to inspire youth interest in the art. For her dedication to poetry, she was awarded an honorary doctorate from Rollins in 1928. She published compilations of poetry in addition to four of her own volumes; one of these, an autobiography entitled *My House of Life*, describes her time in Cheboygan. Other works include the *Little Book of Modern Verse*, *Little Book of Modern British Verse*, *The Door of Dreams*, *The Lifted Cup*, *The Secret Bird*, and others. Jessie was an extensive traveler both domestically and internationally. In the United States, she traveled throughout the country speaking about poetic revival and contemporary poetry of England and Ireland. She also received numerous honorary degrees from European institutions.

Jessie was well regarded in contemporary poetry circles. She was the only female founding member of the Poetry Society of America (later becoming president) and served as the organization's secretary for 10 years. In 1930, she was bestowed with the Gold Medal for Distinguished Achievement (today the Robert Frost Medal), awarded for "distinguished lifetime achievement in American Poetry." When she died in 1948, she left over 1,200 books of poetry and 1,400 letters of literary correspondence to Rollins College. (Author's collection.)

Sheriff John A. Garrow
John Garrow's lifetime bridged an era when Cheboygan's economy changed from lumber to more diversified interests and horses gave way to automobiles. Born in Ontario and raised in Cadillac, Michigan, Garrow started his career in Cheboygan operating a meat market on North Main Street. He later owned Garrow Motor Sales as an agent for Chrysler and Plymouth, while also issuing drivers' licenses as an agent for the secretary of state. He was a city treasurer and avid booster of winter sports and economic development in the community. Garrow's final career move was election to the position of county sheriff in 1943, a position he held for nearly 10 years (1943–1952). (Above, courtesy of the Historical Society of Cheboygan County Inc.; below, author's collection.)

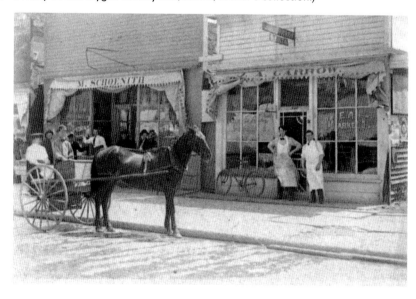

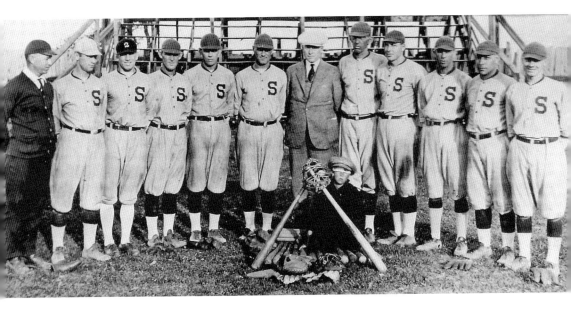

John C. Rittenhouse

John Rittenhouse (above, center) was the proprietor of the Rittenhouse Rustic Furniture Company, a manufacturer of cedar furniture that was marketed to cabin and cottage owners. In his early life, he owned a store on Mullett Lake, but around 1901 he partnered with J.T. Lombard and operated the firm of Lombard and Rittenhouse, making cedar ties and poles. Later, he struck out on his own when he ventured into furniture making. He also owned a Studebaker dealership and sponsored the semi-professional Cheboygan Baseball Club, known as the Studebakers. Rittenhouse furniture is widely sought after and remains a desirable collectible to this day. The image of Breaker's Bar in Topinabee below shows many examples of the style. (Both, author's collection.)

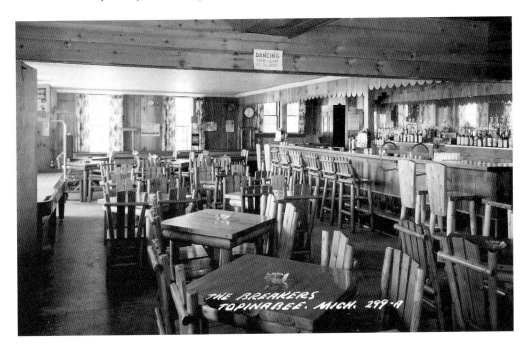

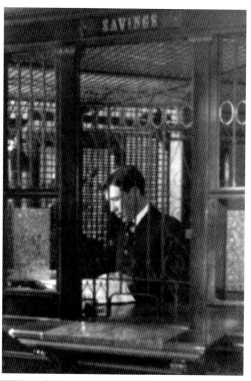

Ernest C. Liebner

At left, Liebner is hard at work at the First National Bank in this image from 1909. While banking may have been his day job, the family business was Inland Route cruises. After a conversation with his father, August, in 1908, the father and son team researched ready-made boat kits, which led to the purchase and construction of the *Ida L.*, launched in June 1909. Their company, the Liebner-Davis Line, ferried passengers along the scenic Inland Route between Cheboygan and Topinabee or Indian River, at which point Charles Davis's *Tourister II* took them to the end of the 41-mile route. Inland Route cruises had been popular for decades, leading to a bustling tourism business in the communities along the waterway. Summer resorts and hotels popped up along the route as well, making it synonymous with summertime relaxation and rejuvenation. Below, the *Ida L.* and *Tourist* meet up in Indian River, with passengers and baggage on the dock. (Left, courtesy of Mary Liebner; below, author's collection.)

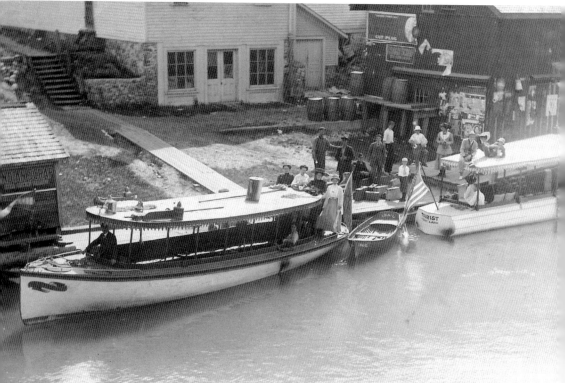

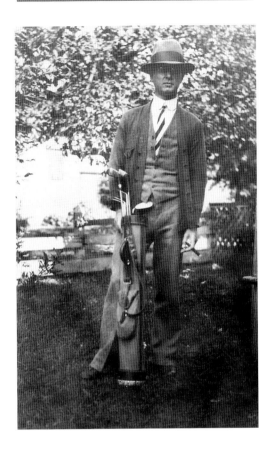

Henry C. Friday

Henry Friday was born on October 25, 1893, the son of Belgian immigrants Homer and Octavia Friday. Early in life, he attended seminary in Milwaukee while preparing to become a Catholic priest. Deciding that his calling was elsewhere, he returned to Michigan. In failing health, he was briefly confined to a hospital in Grayling. Here he met the woman who would become his wife, Catherine (Tirk) Friday. They were married in September 1916 and had eight children. Returning to Cheboygan, Friday entered a career in banking. He began as a bookkeeper for the Cheboygan County Savings Bank and joined the Cheboygan State Savings Bank as assistant cashier around 1922.

In 1931, Friday was hired to become cashier of the new Citizens National Bank. During World War II, he devoted much of his attention to selling war bonds. He appeared on local radio to drum up support for the war effort and advocate purchasing bonds. He received a citation from the US Treasury "for patriotic service to the nation during the seven war loan drives of World War II and in the final Victory Loan drive." Friday was responsible for the bank issuing more than three million dollars' worth of war bonds.

Friday was an avid golfer, bowler, and trout fisherman. He was treasurer of the Cheboygan Golf and Country Club and a member of the Cheboygan Sportsmen's Club. He was also a Past Grand Knight of Cheboygan Knights of Columbus Council 791. After a two-week illness, he passed away on July 26, 1945, at the age of 51. He was a well respected man in Cheboygan and the banking community; Cheboygan's mayor issued a proclamation requesting "that all business places close . . . so that all who wish may attend the funeral services." Al Weber of the *Cheboygan Observer* eulogized him best: "Henry came up a farmer boy, honest, untiring, unafraid, never refused a responsibility or an obligation . . . and now Henry has gone, being taken from the scene when so much [is] needed, and with so many depending upon him, and from a three million dollar institution that he has done so much to make possible." (Author's collection.)

M.D. Fralick and Sam Fralick Jr.
The Fralicks have a long history of being boosters of Cheboygan. M.D. Fralick (left) started a Texaco gas station at the corner of Main Street and Mackinaw Avenue in 1921, and grandson Sam (below) started working there about 1938. M.D. pursued a number of other business interests as well, including the Ritz and Kingston Theatres and wholesale fuel distributing. Along with R.W. Lund, they purchased the paper mill to prevent it from being scrapped, later selling it to American Paper Company. Sam went on to own the Texaco station after his father's premature death and operated it until 1972. He also sold real estate and is involved with Rotary and the Salvation Army. Through his entire life, he has shown unbridled optimism about Cheboygan and its future. (Both, courtesy of Sam Fralick Jr.)

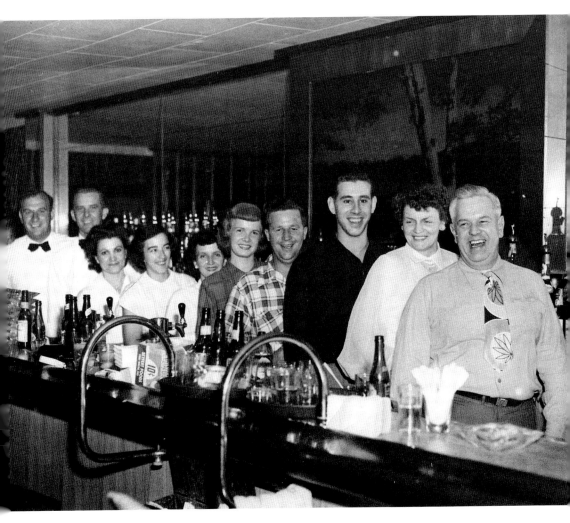

The Gaiety Bar
Many Cheboyganites enjoyed time spent at the Gaiety Bar and bowling alley, located just across the street from Fralick's Texaco station. Sam Fralick Sr. owned the Gaiety, which had a bowling alley next to it, connected by a partition. Many big band acts played in the venue, which could seat up to 450 people. Here, a group of friends pose behind the bar; from left to right are Eddie Meden, Rollie Fisher, Vi Woods, Cina Van Paris, Thelema Merchant, Betty Faye Clune, Bucky Vieau, Dick Van Paris, Connie Fralick, and Sam Fralick Sr. (Courtesy of Sam Fralick Jr.)

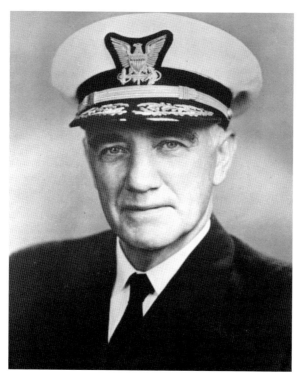

Commandant Adm. Edwin J. Roland (ABOVE AND OPPOSITE PAGE)
The US Coast Guard cutter *Mackinaw* (WAGB-83) arrived in Cheboygan on December 30, 1944. Roland was the *Mackinaw*'s first commander, and she was the first heavy-duty icebreaker ever built. A 1929 graduate of the US Coast Guard Academy, by the time Roland arrived in Cheboygan, he had already served on several other vessels and had taught at the academy. During World War II, he was commander of an escort division that accompanied convoys from the United States to destinations in the Mediterranean Sea.

It was essential to the war effort that the shipping season in the Great Lakes be as long as possible. The result was the construction of the *Mackinaw*, and Roland served on her for two years. He received a Coast Guard Commendation Letter for his service on the Great Lakes, citing him for icebreaking on an unprecedented scale. After his time on the *Mackinaw*, Roland became commandant of cadets at the academy, and later rose to the position of deputy chief of staff of the Coast Guard. In 1956, he was advanced to rear admiral and held the dual post of commander of the Eastern Area and commander of the Third District, New York. In June 1962, he was named admiral and commandant of the US Coast Guard, the top position in the Coast Guard, responsible for all its activities and overseeing all active military, reservists, civilian employees, and volunteers. He is seen opposite above with President Kennedy and Treasury Secretary Douglas Dillon in 1962. During Roland's administration, he handled Cuban exodus operations in Florida, conferred with Naval Coastal Surveillance Forces in Vietnam, and implemented the ubiquitous "racing stripe" emblem painted on all Coast Guard vessels and aircraft.

Roland was recognized throughout his life for his leadership and professionalism. He was awarded the Legion of Merit, Distinguished Service Medal, Coast Guard Commendation Letter, Navy Commendation Ribbon, Knight Commander of the Order of the Italian Republic, American Legion Distinguished Service Medal, and many others.

While Cheboygan was a brief stop in Roland's career, the Coast Guard has had a strong and very visible presence here ever since. The original *Mackinaw* is now a museum ship in Mackinaw City after being replaced by the new *Mackinaw* (WLBB-30) in June 2006. (Above, courtesy of the US Coast Guard; opposite page above, White House photograph; below, courtesy of the USCG.)

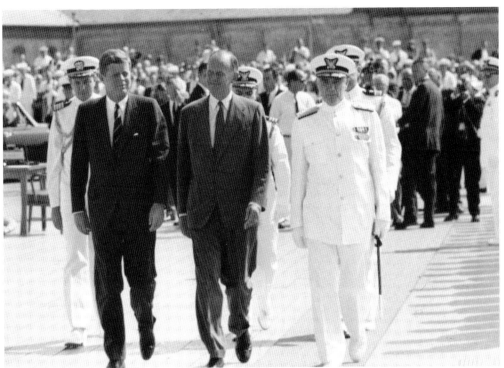

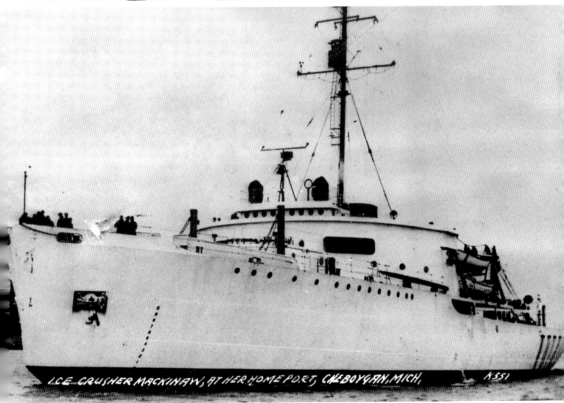

ICE CRUSHER MACKINAW, AT HER HOME PORT, CHEBOYGAN, MICH. K551

Alfred Weber

The stoic look on a young Alfred Henry Weber, seen here, remained on his face for most of his life. Born in Ohio in 1870, Weber moved with his family to the Kalamazoo area to farm around 1880. Dedicated to reporting community news, he got his first job at age 17 for the *Nashville News* (Michigan). His newspaper career would then take him to a variety of places, including Chicago, Ann Arbor, Charlotte, Hancock, and Hastings. Looking to come north, Weber took a job at the *Cheboygan Democrat* as a printer about 1905. He would go on to purchase that paper and, being an ardent Republican, soon renamed it the *Cheboygan Observer*.

Weber was Cheboygan's mayor from 1927 to 1929 and a charter member of the Cheboygan Rotary Club, president of the chamber of commerce, president of the Michigan Press Association, and a national delegate to the 1932 Republican National Convention in Chicago. He sold the *Observer* in 1945 to Myrt Riggs. (Courtesy of the Historical Society of Cheboygan County Inc.)

George M. Humphrey
Born in Cheboygan in 1890, Humphrey attended the University of Michigan and was named by Pres. Dwight Eisenhower to be the 55th secretary of the treasury. Serving until 1957, Humphrey was a fiscal conservative who believed that the less the government got involved in everyday life, the better it would be for the American people. A trusted advisor to the president, Humphrey urged lowering taxes and government spending, which led to a balanced federal budget in 1956, the first in five years. Serving as secretary of the treasury until 1957, his signature appeared on US currency while he was in office. Humphrey is shown above on January 21, 1953, as he is sworn into office by chief justice Fred Vinson while President Eisenhower looks on. (Both, author's collection.)

Sen. Charles E. Potter

Born in Lapeer, Michigan, in 1916, Charles Potter moved to Cheboygan to take a job as the administrator of the Bureau of Social Aid in 1938. In 1942, he enlisted in the US Army and served in Europe. He was seriously wounded in France and lost both his legs as a result. He was awarded two Silver Stars, the Purple Heart, and the French Croix de Guerre with silver star. Potter was discharged with the rank of major in 1946.

Following his wartime service, Potter entered the public field after being elected to the US House of Representatives in 1947 to fill a vacant seat. He would go on to be reelected two more times before winning election to the US Senate in 1952, a position he would hold until 1959. After his career in politics, Potter was an industrial consultant, international securities executive, and member of the American Battle Monuments Commission. He resided in Queenstown, Maryland, until his death in 1979 and is interred in Arlington National Cemetery.

Potter's 1965 memoir, *Days of Shame*, outlines the ways in which Sen. Joseph McCarthy intimidated celebrities, officials, and ordinary citizens during the Red Scare of the 1940s and 1950s. Potter served with McCarthy on the Senate Government Operations Committee and had a firsthand perspective into the world of McCarthyism and rampant accusations of communism throughout American society. Senator Potter was a witness to this bizarre and confusing time in American history and used his experience to warn readers of the dangers of power and corruption. (Courtesy of the US Senate Historical Office.)

Henry J. Heike

A man whose harmless past is steeped in unsubstantiated rumor and tall tales, Heike's rather mysterious legacy comes from his construction of at least three tomb-like cairns around the Cheboygan area. For many years, legend had it that crossing one of the tombs the wrong way or removing a stone would spell certain doom. In reality, Heike built these stone monuments where he saw religious visions or dreams and included a message stating so. A bricklayer from the Detroit area by profession, Heike moved to the region by 1950 and lived in isolation in a home he constructed a few miles from town. He liked his solitude but would walk to town from time to time for provisions and get a ride home from whoever would give him a lift. Neither Heike nor anyone else is buried at the so-called tombs, all of which have now fallen victim to vandalism and weather. (Both, courtesy of Jim Chimner.)

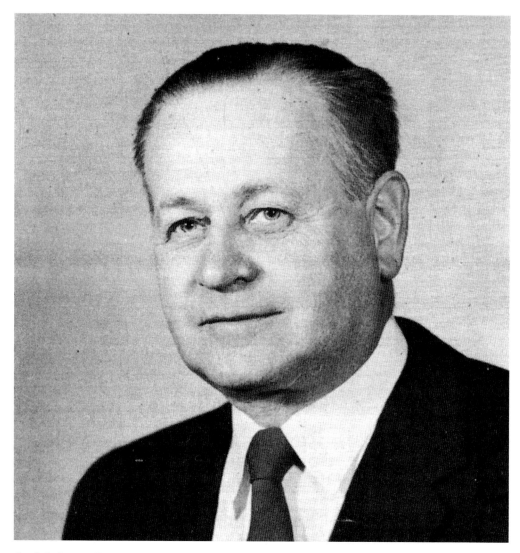

Carl A. Leonall.

An active member of the community for his entire life, Leonall began working at Sangster and Riggs City Drug Store in 1919. He later bought the store, and it became known as the Leonall Drug Store, later operated with his wife, Elizabeth, and son Victor. Leonall was one of the organizers of the Cheboygan Boosters Club, which later became part of the chamber of commerce. He was on the city council and heavily involved in education and tourism promotion throughout the Northern Michigan region. He was one of the original incorporators of Cheboygan Community Hospital and served two terms as president of the board. In 1971, a committee of the Cheboygan Centennial decided to dedicate the anniversary's book in his honor, recognizing him for playing a major role in Cheboygan's history. (From *Cheboygan Centennial 1871–1971.*)

Cullen Landis

Landis was a star of silent movies and appeared in over 100 films. He also appeared in the first full-length film with dialogue throughout, *Lights of New York*, alongside Helene Costello. Landis came to Cheboygan for the first time in 1942 to encourage the sale of war bonds. Along with a tank and crew, they were in the area to make a film on tank operations. In a scene more typical in Hollywood, fans surrounded Landis seeking a photograph and autographs. Landis served during the war by making films not just at home, but also in the South Pacific and later all over the world. After he retired from acting as a cameraman and film director for the US State Department, he made his home along the Cheboygan River with his wife, Jane Grenier, of Topinabee. (Both, author's collection.)

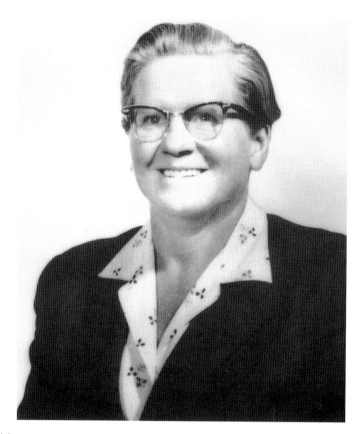

Doris E. Reid

Many children born in Northern Michigan were likely impacted by Doris E. Reid, though now in adulthood they may not realize it. After receiving her registered nurse degree form Traverse City State Hospital in 1936, she was offered a scholarship to the Frontier School of Midwifery in Wendover, Kentucky. After completing her certified midwife degree in 1943, she stayed in the rural region, administering to the people of the Kentucky hills for six years. Reid returned to Northern Michigan in 1950 and was the area's only certified midwife—a designation that would not be recognized by Michigan until 1986.

Upon her return, Reid began working as a public health nurse for District Health Department No. 4. She retired in 1973 as a nurse coordinator and nursing supervisor. Her steadfast dedication to her profession earned her numerous accolades, including being named by the American Nurses Association as the most "Be-Involved Nurse, State of Michigan," in 1970. She was also honored by the American College of Nurse-Midwives and inducted as an honorary fellow. Though she had officially retired, Reid remained active in her field as president of the Northern Tri-County District Nurses Association, life member of the Michigan Nurses Association, and a member of the Burt Lake Christian Church for 72 years, plus many other local organizations. She was also a voracious reader, avid gardener, and enjoyed hunting and fishing. Still, her passion was always helping people, right up until her passing in 2001 at the age of 86.

In recognition for Reid's pioneering spirit, selfless sacrifice, and dedication to midwifery and area health, in 1992 the new District Health Department building was named in her honor. That same year, she also penned a book, *Saddlebags full of Memories*, in which she recounted what it was like to be a midwife in Kentucky during the 1940s. In it, she noted what truly gave her the passion to do what she did for so long: "The only worthwhile compensation for such hard, long hours is knowing you have been of service to someone in a time of need. That is the rent we pay to God for the privilege of living on earth." (Courtesy of the Cheboygan County History Center.)

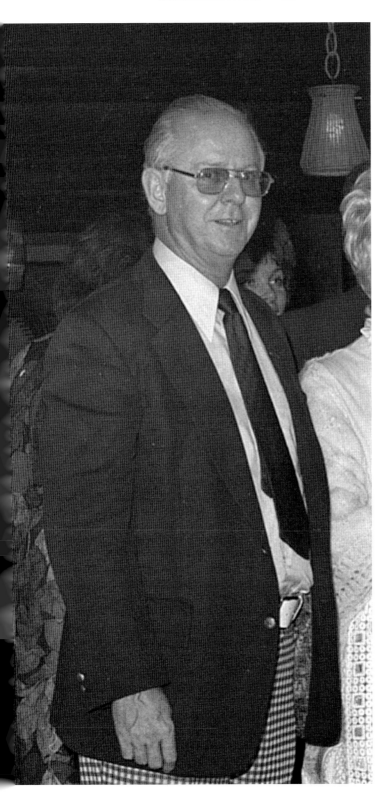

Archie E. Barnich
One of Cheboygan's best-known businessmen at the time of his premature death in 1973, Archie Barnisch was a Cheboygan native who spent his entire professional career in the community. After graduating high school in 1931, he was employed in the insurance industry for five years before starting his own company in March 1936. After serving in the Army during World War II, he returned to Cheboygan and became more active in local affairs, including running political campaigns and reorganizing the city government. Barnisch also invested his time with various organizations, including the Knights of Columbus and Kiwanis Club and as chairman of the board at Citizens National Bank. In 1961, William Kavanaugh and Gary Cooper joined the company and it took on the name it retains today—BKC Insurance. (Courtesy of Jerry Pond.)

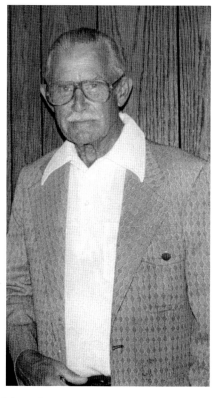

Dr. Walter Larson

Few physicians could claim to have delivered three generations of the same family, but Dr. Walter Larson was not an ordinary physician. He started his career charging $1 for office visits and $2 for house calls; if patients did not have the cash, he accepted potatoes as a form of payment. Credited with delivering over 4,000 babies (he thought it was closer to 5,000), Larson practiced medicine in Cheboygan for 32 years.

Larson retired in 1974, but two years later, Cheboygan honored him with a special celebration. A parade was held in his honor, followed by a celebration in Washington Park. There, the city and Kiwanis Club presented plaques to the doctor, the citizens of Cheboygan presented him with a silver trophy to show their appreciation, and he was made an honorary citizen of Mackinaw City. He is seen here giving remarks at the gathering. (Above, courtesy of the Historical Society of Cheboygan County Inc.; left, courtesy of Jerry Pond).

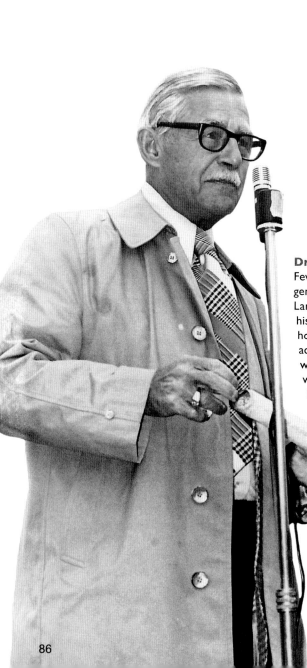

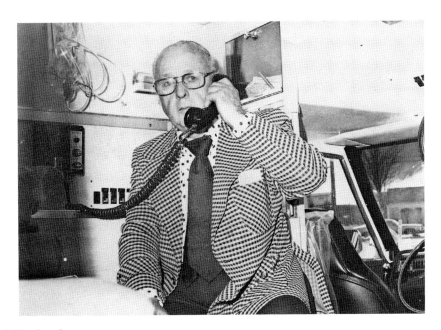

Harold Ireland

When Harold Ireland came to Cheboygan in 1937, he wasted no time in becoming a positive force in the community. In that year, he established a Gamble's hardware and variety store. He received numerous awards from the Gamble-Skogmo Corporation for success and longevity for his store. In 1961, he and his wife, Marion, started the Ireland Ambulance Service, providing emergency transportation around the clock to Community Memorial Hospital or other regional healthcare facilities. The Irelands won accolades from various community organizations for the services they provided via their ambulances. In the image above, taken the day before he died, Ireland tries out a new communication system between ambulances and hospitals. (Above, courtesy of Jerry Pond; below, courtesy of Doug Dailey.)

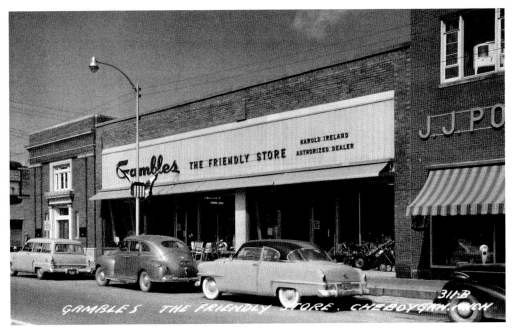

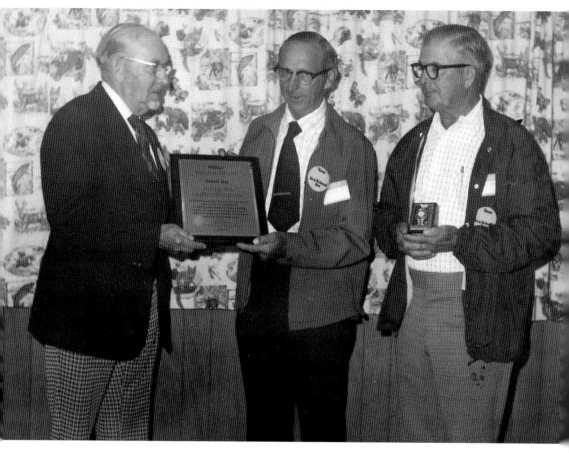

Frank Bur

The credit union movement in the Cheboygan area began in 1950 with the establishment of the Alverno Parish Federal Credit Union. Bur (center) was a charter member and its first treasurer, and he remained on the board of directors until the institution merged with the Cheboygan Community Federal Credit Union in 1964. Bur then served on that board as well, becoming the longest serving officer of the credit union movement in Cheboygan. In recognition of this, he was presented with the Credit Union Service Award Plaque in 1973. He is seen here receiving the award from CCFCU president N.J. Christian, with first APFCU president Lloyd Gouine at right. In 1974, the credit union changed its name to Straits Area Federal Credit Union. (Courtesy of Straits Area Federal Credit Union.)

Arthur "Art" Michelin

A popular restaurateur, Michelin was a true community booster who was committed to his hometown. His first restaurant venture, the Hut, was a small building on Main Street that boasted, "We serve 500 people, ten at a time." He later expanded and renamed it the Maison de Pierre, offering fine dining in an elegant atmosphere. Michelin was socially active throughout his life, helping to organize the Knights of Columbus Fourth Degree and Kiwanis Clubs in Cheboygan and the Cheboygan Catholic High School. He was also on the rationing board during World War II, was a trustee of Community Memorial Hospital, and held many other positions in town. Along with Myrt Riggs, he helped rally support among legislators for financing the construction of the Mackinac Bridge. Compassionate, honest, and dedicated, Michelin made a profound impact on Cheboygan and the entire region. (Above, courtesy of Doug Dailey; below, courtesy of Jerry Pond.)

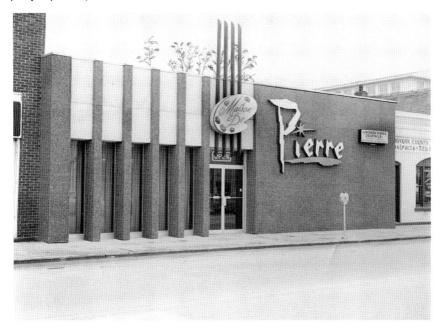

Mitchel and Irene Andrews

In 1952, Mitchel and Irene Andrews (pictured with grandson Bob) purchased the former C.F. Smith Company Orchards just outside Cheboygan. Later, their son Marty would take an active role in managing the business. The Andrews called their new venture Northern Orchards, and they produced everything from fresh-picked apples and cherries to cider. Their products were sold to grocery chains and also manufactured into applesauce and baby food. Many locals worked at the orchard from time to time, especially around harvest season, when the total number of employees was over 275. The annual harvest led to community celebrations like the Apple Festival, which featured a coronation ball and crowning of a queen, a parade, pie baking and eating contests, a pancake cookout, and more. A series of losses with weather in the early 1970s led to the Andrews selling the orchard, and it closed three years later. Still, memories of picking fruit in the orchard remain cherished by many Cheboyganites. (Courtesy of the Andrews family.)

Marty Andrews and Orchard Work

While the harvest was only collected at certain times of the year, the process of running an orchard was a yearlong affair. From pruning to picking, packing to juicing, Northern Orchards (seen above just after purchase) provided employment year round. To ensure good quality fruit meant constant maintenance, as can be seen in the photograph below of Marty Andrews posing with equipment used to spray newly planted trees. (Courtesy of the Andrews family.)

William Michael "Mike" Glenn

Mike Glenn is fondly remembered in Cheboygan for his bait shop on Water Street, as well as his keen sense of humor and quick wit. He, along with his wife, Pearl, opened up Glenn's Bait Supply on Water Street in the basement of their home about 1943. The goal was to keep his kids off the street, but the endeavor soon turned into a full-time job for Glenn. He started selling night crawlers and minnows, which he caught himself, but soon began stocking tackle, hooks, equipment, and other fishing supplies. The business grew quickly, and in 1949 an addition was put on the front of the home to serve as a formal storefront. Groceries were soon available in the store, as were larger items such as fishing boats and motors. Glenn's Bait Supply became the backdrop for many newspaper images as lucky hunters and anglers posed with their trophy buck or record-setting catch. In the mid-1970s, the business was handed off to his son Robert.

Glenn was an active community man as well. He was appointed by Gov. G. Mennen Williams to the Michigan Waterways Safety Study Commission and was president of the chamber of commerce when Procter and Gamble came to town in 1957.

There are many tales of Glenn's quick wit and humor, but he also gave some valuable fishing advice. According to his daughter Geraldine, he said that the secret of ice fishing was to take a can of peas, a floating brick, a can of pepper, and a baseball bat. Cut a hole in the ice, put the floating brick in the hole, place some peas on the brick, and sprinkle them with pepper. When the fish come up to take a pea, they will sneeze from the pepper, and one can hit them on the head with the baseball bat.

He also had a recipe for carp. Put the carp on a plank, cover it with cow manure, and bake it in the oven for an hour at 350 degrees. After you take it out of the oven, throw the fish away and eat the plank. (Courtesy of Jerry Pond.)

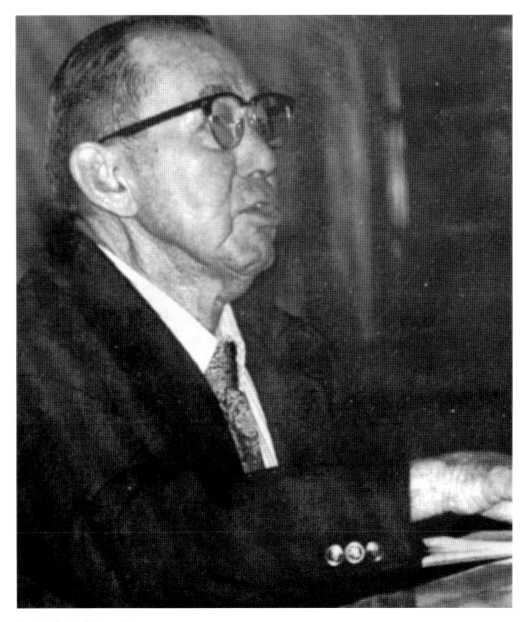

Louis A. LeBlanc Sr.

Likely Cheboygan's most controversial mayor, Louis LeBlanc was certainly one of the more colorful characters in the city's history. LeBlanc was known for his brusque language, outrageous comments, and his exceedingly outspoken demeanor. Still, he billed himself as a man of the people during his tenure as mayor from 1992 to 1996. Though unconventional, he was popular enough to survive a recall election in 1993. He tackled issues that were unpopular and worked to make sure that everyone in the city was represented. LeBlanc prided himself on being available at any time, day or night, to listen to citizen concerns. Loved by some, despised by others, but remembered by all, LeBlanc believed in Cheboygan and its people. (Courtesy of the *Cheboygan Daily Tribune*.)

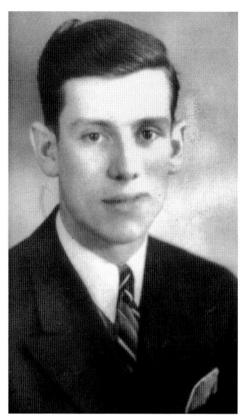

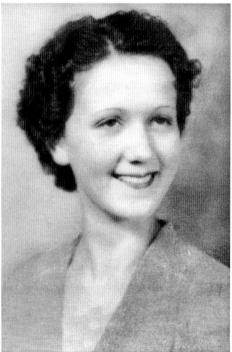

Charles and Alice LaHaie.
"Chuck" LaHaie was active in the real estate business for many years in Cheboygan and is fondly remembered for his professionalism and kind and caring demeanor. He undertook several development projects in the area and assisted with right-of-way and property acquisition for Michigan and the federal government for the Sleeping Bear Dunes, Pictured Rocks, and Apostle Islands National Lakeshores. Charles was also a city mayor, member of the board of education, and an avid supporter of Cheboygan and its people. He insisted that any accomplishments in his life were due to his wife, Alice, and her constant support through 63 years of marriage. (Both, courtesy of Chas LaHaie.)

CHAPTER FOUR

Legends Made,
Legends in the Making

Despite seemingly insurmountable odds, Cheboygan survived a massive economic decline. Not only had the predominant industry crashed, but so too had the entire national economy. The city crawled out of the Great Depression due in part to World War II but also to those who had made a commitment to the area.

Cheboygan had been reborn. Thanks in large part to the efforts of Myrt Riggs, the new Procter and Gamble mill provided hundreds of jobs. Other smaller industries led to a more diversified economy. Tourism continued to attract visitors, especially after the Mackinac Bridge opened in 1957. New residents also arrived, many of them having retired from the auto industry and now rediscovering their roots. Others made a permanent move to the area after having spent summers or vacations here and now realizing that the pure north was exponentially superior to the hustle and bustle of city life.

The city itself changed a great deal as well. Many old buildings were lost to fire or torn down in the name of progress, but others were saved. People like Joyce and Quincy Leslie and Pam Westover were instrumental in saving the historical Cheboygan Opera House, now a center for the performing arts. New structures were built as well, many designed in part by architect and former prisoner of war Jim Muschell. As these events unfolded, Jerry Pond captured photographs of decades of triumph and tragedy, while Gordon Turner wrote not only about the present but also the past, preserving it for future generations.

A legendary local can take many different forms. From football coach Jack Coon to the philanthropic work of Gordon and Francis Spies, becoming legendary is not something for which there is a simple definition.

Of course, there are many, many people who have made an impact and will never receive notoriety. Many work behind the scenes or shun the spotlight and in so doing make Cheboygan a better place whether they know it or not. This is the case today, and it was the case all the way back in 1845 when Jacob Sammons built the first permanent home here. Home is a place to feel welcome, to build upon, to constantly strive to make better. Cheboygan's legendary locals, known and unknown, have strived to do exactly that.

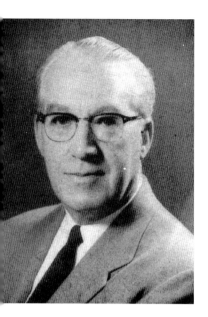
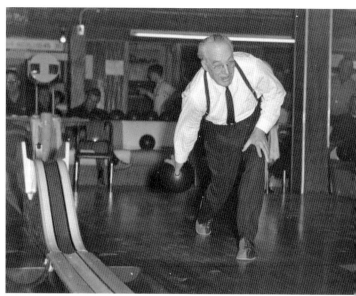

Myrton "Myrt" Riggs.
One would be hard pressed to find a citizen more dedicated, loyal, or passionate about Cheboygan and its people than *Cheboygan Daily Tribune* publisher Myrt Riggs. Born and raised in the community, his first job was at the paper while a schoolboy. Riggs briefly went to work at the Packard plant in Detroit, but soon returned home and within a few years was back working at the newspaper. He would continue to work there for the rest of his life, but Riggs, always community minded, tirelessly sought to make his hometown a better place to live and work.

Riggs, along with M.D. Fralick and Robert Lund, pooled their resources and bought the paper mill during the Great Depression to prevent it from being scrapped—a move that, years later, would provide jobs for hundreds of locals. Riggs helped to secure the Cheboygan Industrial Park and entice new businesses to locate there (in all, he was at least partly responsible for bringing 15 industries to Cheboygan). He spearheaded an effort to get the Coast Guard cutter *Mackinaw* to locate here, while also sitting on various economic development councils to support Northern Michigan business growth.

One of Riggs's largest accomplishments was helping to secure funding for the construction of the Mackinac Bridge. As the Mackinac Bridge Authority tried to sell its bonds to finance construction, the state legislature stalled its decision on an annual appropriation for bridge maintenance. Riggs and Art Michelin wrote to every Michigan newspaper, radio station, and lawmaker to encourage them to express their support for the appropriation. It worked—the bonds sold, and financing the bridge became a reality.

Riggs was involved in countless other projects, including heading a movement to build Community Memorial Hospital, the Boys Club (now Cheboygan Recreation Center), establishing the annual Northern Michigan Open golf tournament, and many others. He was recognized time and again for his accomplishments, including an honorary doctor of letters degree from Central Michigan University.

After a very busy career with both the newspaper and community development, Riggs died in 1977 at the age of 78. (Left, author's collection; right, courtesy of Jerry Pond.)

Alta Riggs

Wife of *Cheboygan Daily Tribune* publisher Myrton Riggs, Alta was a community leader like her husband. She is credited with starting the Kids Day and Parade in 1934, which included races for the children, free ice cream, and a bathing beauty and lifeguard contest for children under six. She was also in charge of the Paleface Indian Maidens and coronation ceremonies for local celebrations, such as homecomings and carnivals. Riggs was president of the Cheboygan Women's Club and was named Woman of the Year by the Cheboygan Business and Professional Women's Club. After Myrton died in 1977, she became publisher of the *Tribune* and retired in 1980. (Above, courtesy of *Cheboygan Daily Tribune;* below, author's collection.)

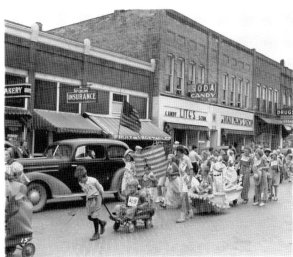

Gordon "Scoop" Turner

There are few people who have made as much of an impact in Cheboygan as Turner. In 1927, he came to town for a three-month summer job at the *Cheboygan Daily Tribune* to gain experience that he could take with him in search of a bigger job in a larger city. Those three months turned into 68 years. At the time, the *Tribune* offices were located in the Ottawa Hotel, and he was paid $10 a week. He received job offers from much larger papers, but as Turner became more and more involved in Cheboygan, he fell more in love with the town and its people.

Over the years, Turner covered nearly every type of event imaginable in town. Punching out his stories on an old typewriter that he continued to use for the rest of his career, he chronicled everything worthy of reporting in the newspaper. He attended seemingly every high school basketball and football game while working as sports reporter. But Turner's greatest legacy to local news may be in his history stories. He was a meticulous researcher and spent many hours combing over bound editions of yellowed newspapers of yesteryear. While conducting interviews, he would pick the memories of old Cheboyganites and write about businesses, eras, and people long since passed. Indeed, without Turner, many historical accounts and details would have been lost to the ages.

Turner's long and storied career rightly earned him the nickname "Mr. Cheboygan." But in his personal life, he was no less attentive. A kindhearted and soft-spoken man, he had nary an ill word to say about anyone and firmly believed in putting his Christian faith into practice. He taught Sunday school for 30 years and was also heavily involved in the Boy Scouts, Kiwanis Club, and Red Cross.

Turner saw, reported, and brought the community together in a way that few people ever could have. He died in 1995 at age 89, less than a week after filing his last story. He is seen above right sitting in the park that was named for him in 1979. (Left, courtesy of the Historical Society of Cheboygan County Inc.; right, author's collection.)

Scoop at the Office
Turner never really considered retirement an option and even celebrated his birthdays at work. He is show in these images taken on his 60th (above) and 70th birthdays while at the office. In the image on the left, he playfully holds one of the dolls that Community Memorial Hospital sold as fundraising items. (Courtesy of Jerry Pond.)

Alfred E. "Bunk" Bonsecours

On call for over 60 years with the Cheboygan Fire Department, Bunk Bonsecours was a legend throughout the community and the Northern Michigan region. After graduating from Cheboygan High School, he worked at the family John Deer–Studebaker dealership and then enlisted in World War II. Serving with the US Army in the Philippines, he returned home to work at the American Paper plant, selling cars after the plant closed. He was also a long-time bus driver for Cheboygan area schools.

But Bunk is best known for his role in protecting the public. He became a volunteer firefighter before World War II and resumed that calling after his return. He later became assistant chief, and in 1971 became chief, a position he held until his death in 2003. Bunk was always calm and cool under pressure, even while facing the most intense blazes. His encyclopedic knowledge of how to fight fires likely contributed to this, but that also made Bunk an extremely effective leader. "You learned real quick to do it the way he taught you, and you would find out in a hurry if you did it wrong," noted chief of police Kurt Jones at Bunk's passing. "He was a man who had forgotten more about fighting fires than most people ever know . . . he had a special way of giving directions and taking care of business. He would save the building on fire and those around it."

Bonsecours ran a tight ship, running the fire department "like a drill sergeant" according to one account. Another account asserted, "He ran the department like he did in the service. There's the right way, wrong way and Bunk's way. And we did it Bunk's way. Invariably, in 99 percent of the cases, that was the right way." Still, he was kind hearted, often visiting friends and acquaintances in the hospital with a genuine concern. Respected for being both a gentleman and a fearless public servant, Bunk's legacy will always live on in the ranks of Cheboygan's Department of Public Safety. (Courtesy of the Historical Society of Cheboygan County Inc.)

Quincy and Joyce Leslie

The Leslies have touched the lives of many in the Cheboygan community. Quincy C. Leslie, born in Northport, Michigan, in 1917, moved to the community as a young boy and started his working life at the *Cheboygan Daily Tribune*. After graduating from high school, he furthered his education and became a teacher in rural county schools. After being drafted during World War II, he married his sweetheart Joyce in 1942 before being assigned to various posts within the United States. He later became a life member of the American Legion and was parade marshal for over 50 years.

After the war, Quincy owned and operated Leslie Television-Radio Sales and Service downtown. He later received his bachelor's and master's degrees from Central Michigan University and taught for 15 years. He also served the city on city council and as mayor and was active early in the formation of the Historical Society of Cheboygan County. He served on the board of the First Church of Christ, Scientist, and was a Sunday school teacher and reader at church services. Quincy also had a love for trains and was an avid model railroader, often welcoming fellow hobbyists into his home. Along with Joyce, he was a volunteer and usher at the Cheboygan Opera House. He passed away in 2011 at the age of 93.

Joyce Leslie began teaching piano in the 1940s, and as a result she has sparked a love of music in many of Cheboygan's youth. Originally charging just 50¢ per lesson, she went on to teach hundreds of local children and adults the joy of music. Joyce later worked at the local newspaper, volunteered with Brownies and Boy Scouts, and has been a soloist at church for over 60 years. She also was instrumental in initializing the effort to renovate the historical Cheboygan Opera House. Once nearly doomed to meet the wrecking ball, a community effort spared the gracious building, which today is a highlight of the city. Joyce went on to both work and volunteer at the restored Opera House.

Together, the Leslies are well known for their community spirit, kindheartedness, and desire to make Cheboygan a better place to live. (Both, courtesy of Joyce Leslie.)

Mary "Lila" L. France
Lila France was a renowned fixture in the local school system for 44 years. She taught in Cheboygan County rural schools, was principal of Mackinaw City Elementary, and served 25 years at West Side Elementary. Lila touched the lives of many Cheboygan children while also being active at St. Mary/St. Charles Catholic Church and with the Daughters of Isabella for over 65 years. (Author's collection.)

Michele Andrews

Postsecondary education in Cheboygan has expanded in large part through Michele Andrews's efforts as director of off-campus programming for North Central Michigan College. While NCMC classes have been taught in Cheboygan since 1973, it was not until 1999 that Cheboygan was considered an official site for the Petoskey-based college. In 2011, the new Straits Area Education Center was established, and local students can now take a wide variety of classes all in one location and without having to make a long drive. Andrews also teaches in addition to her administrative role, noting that "nothing is more fulfilling than to see students working hard to create their own opportunities and futures." (Author's collection.)

Lois Ballard

Ballard had a varied career in the hematology field, which took her from Michigan to New York and throughout the state of Georgia. She invented multiple machines to improve efficiency and simplify the process of analyzing blood collection. In 1994, she retired to the Cheboygan area. A founding member of the Aloha Historical Society, Ballard collaborated with others interested in local history to publish *Aloha and Aloah: Now and Then*. She became active with the Historical Society of Cheboygan County, eventually becoming its president and improving artifact organization and display. She has also volunteered at the Opera House and worked at the chamber of commerce. Passionate about whatever she is committed to, with Ballard, "You always know where you stand." (Courtesy of Lois Ballard.)

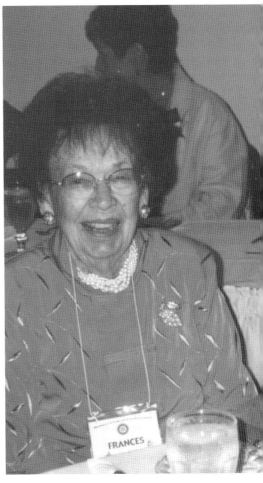

Gordon and Frances Spies

Among Cheboygan's most generous benefactors are Gordon and Frances Spies, two citizens who touched the lives of nearly everyone in the community. As a boy, Gordon operated a riding stable in Topinabee, and when World War II broke out, he enlisted in the military, serving with the Army Air Corps and seeing action in Europe. In 1949, he married Frances in Ocala, Florida, and returned to Cheboygan. He became a builder, credited with constructing everything from roads and homes to condominiums and commercial buildings.

The Spies will best be remembered by their generosity. Though many of their gifts were kept quiet, many of their contributions can be seen throughout the community. Examples include Spies Heritage Hall at the Cheboygan County History Center, the property upon which Hospice House was built, $25,000 to the Garfield Avenue Soccer Field, the Cheboygan Rotary Club, and many more.

Jack Coon

Cheboygan takes great pride in its high school football team, and Coach Coon has been an instrumental part of that program since 1985. He stresses that although winning is fun, the most important part of coaching is watching student athletes learning through sports and seeing the community share in exciting moments. In 2009, Coon was inducted into the Michigan High School Football Association Coaches Hall of Fame. (Courtesy of Jack Coon.)

James "Bud" Darnell

Since retiring from General Motors and moving to the area in 1995, Bud Darnell has become one of Cheboygan's biggest boosters. Meeting regularly with a group he helped form, the Cheboygan Economic Development Group, he and others have helped to introduce new businesses and educational opportunities in Cheboygan. Always on the scene and on the go, he noted that, "Life's been pretty good to me. I don't mind giving back." (Author's collection.)

Susan A. Eno

Sue Eno has had a long career at Citizens National Bank, beginning in 1971 while still in high school. She became the organization's first female president and CEO in January 2008. While banking has changed considerably since she started, the feeling of working in a community bank has not, and she truly enjoys the personal connection to employees and customers. Eno notes that working for an institution that serves the area and gives back to it is rewarding, but so too is seeing how it helps the community over the long term. "We make a huge impact in the communities we serve, and we do make a difference," she said. "It starts as a child opens a savings account, then they come back to town after college and come to see us when he or she is ready to buy their first house. It's a pretty neat feeling." (Above, author's collection; below, courtesy of Citizens National Bank.)

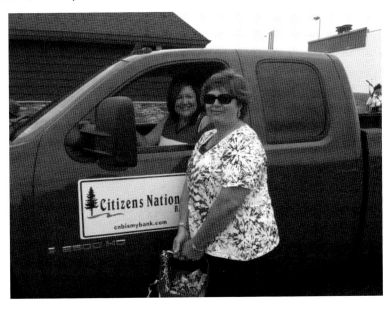

James E. Muschell

Making a difference in his community and the nation, Muschell is not only legendary, but also a hero. Born in Cheboygan, after graduating from Cheboygan High School in 1943 he went into the Army as the United States and much of the world was wrapped up in World War II. At just 20 years old, he found himself in Europe with the 43rd Tank Battalion as the Allies pressed on towards Berlin. Under heavy fire in the streets of Herrlisheim, France, Muschell was wounded after his tank suffered a nearly direct hit from a German tank. As they gathered in a makeshift command post in the basement of a farmhouse, a German Tiger tank drove up and pointed its gun at the house and gave the men an opportunity to surrender. Taken as a prisoner of war on January 17, 1945, Muschell and his comrades faced an uncertain future.

Muschell, who had lost his dog tags jumping out of his tank and could not prove his identity, was sent within days to a slave labor camp with Jewish, Russian, Polish, and other prisoners deemed undesirable. The goal of these camps was not outright murder, but working the prisoners to death. Muschell and others at the camp subsisted on a thin cabbage soup and a bread that was made of rye, sugar beets, sawdust, leaves, and straw. Work consisted of cleaning up bomb damage in the city of Hannover, picking up bricks, and removing dead bodies. By March, he had lost 100 pounds. As the Allies advanced, Muschell's camp was evacuated and the prisoners were marched eastward to Hamburg. But then, on April 13, the men were liberated by the 15th Scottish Regiment. A young United Press reporter named Walter Cronkite interviewed Muschell shortly thereafter. He received many decorations, including two Purple Hearts and the French Croix de Guerre.

Upon returning home, Muschell completed his engineering degree, and in the late 1950s organized United Design Associates. UDA designed many local landmarks, including two bridges and two schools, and has done work in marine design. Muschell has also done a great deal of research into ice pressure and how it affects marine engineering. In 2005, he published *From Bloody Herrlisheim to a Slave Labor Camp*, describing his wartime experiences.

Muschell served seven terms as mayor of Cheboygan. Today, at age 89, he still goes to work every day. (Left, author's collection; right, courtesy of Jerry Pond.)

Jerry Pond

Few individuals in Cheboygan's past have captured the news like Jerry Pond. Born and raised in Cheboygan, Pond started working for the *Cheboygan Daily Tribune* in 1963, capturing images of newsworthy events with a keen photographer's eye. Calling himself an "accidental historian," Pond has photographed most, if not all, historic local events since 1963. He was the only photographer on-scene after the sinking of the *Cedarville* in 1965 and also photographed Pres. Gerald Ford and the First Lady when they visited Mackinac Island in July 1975. For Pond, his career has meant not just taking photographs, but reporting. "I feel a sense of responsibility to the community to report the news," he noted. "The paper is their paper." (Left, author's collection; below, courtesy of Jerry Pond.)

Chief Kurt R. Jones

For almost his entire life, Kurt Jones has been dedicated to protecting the public in Cheboygan. Soon after graduating from Cheboygan Catholic High School and Ferris State University, he served as a county sheriff's deputy for two and a half years. In January 1980, he became chief of the Cheboygan Police Department. Four years later, he became the director of public safety, a position he has held to the present day. Chief Jones is the longest-serving police chief in Cheboygan's history. He has also coached youth sports programs, been active with the Boy Scouts, served as a volunteer firefighter, and has served on the Cheboygan Life Support System's board for about 30 years. Jones has responded to most all of the largest conflagrations and major incidents in the city's recent past, and in so doing has helped preserve life and property on a scale that is impossible to calculate. (Both, author's collection.)

Michael Grisdale
Since hitting the local airwaves in 1980, Grisdale has been a fixture on local radio stations. His voice is instantly recognizable as the soundtrack for local sports, commercials, news, and the popular *Tradio* radio program. He is also a past executive director of the Cheboygan Area Chamber of Commerce and active in many community organizations, including St. Mary/St. Charles Church. He is also a basketball referee, and was formerly with the Northland Players theater group. (Author's collection.)

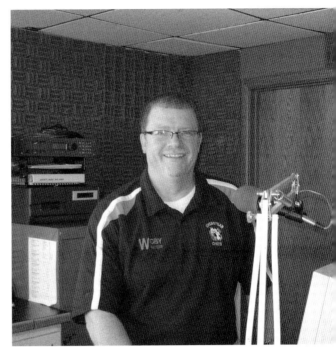

David "Foughty" Fought
Recognizable to nearly everyone in the community, Fought has faithfully guarded the crosswalk at State Street (US highway 23) and Division Street since 1980. He has safely escorted thousands of children across the busy intersection, a job he cherishes. "I love the kids, I don't know what I'd do without them," he said. Fought is also an avid golfer, well known on the links. (Author's collection.)

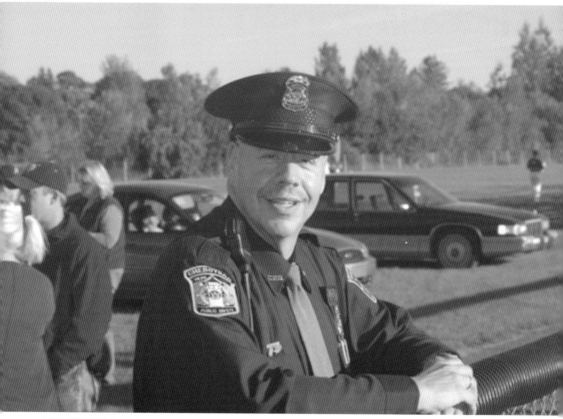

Dan Frazier

A familiar face with area youth and the community as a whole, Frazier was among the first three police officers in Michigan trained in the DARE (Drug Abuse Resistance Education) Program and presented it in area schools from 1987 until his retirement in 2014. In 1984, Frazier began his law enforcement career in Cheboygan and cites the small-town atmosphere and closeness of area residents as great reasons to call the community home. He can also be seen as a DJ for area parties and weddings, high school dances, and graduation parties. His quick-witted humor and jovial attitude have made him a well known and popular figure in Cheboygan. (Both, courtesy of Dan Frazier.)

Ernest "Ernie" and Veronica "Vera" Gildner
In 1946, Ernie and Vera Gildner came to Cheboygan and purchased a cement block plant located on the Cheboygan River and established Cheboygan Cement Products. Five years later, they moved the plant to its current location and have added to it several times since. From their original production capacity of 500 blocks a day, they can now manufacture 12,000. The company produced brick that has literally built much of Cheboygan and the Northern Michigan area.

But the Gildners have done more than just build buildings—they have built community. Always willing to lend a hand with local projects, their generosity can be seen in projects such as the stained-glass windows in the Bishop Baraga School chapel. Vera notes, "We're so glad to be here and do things for the town." The business is now in its third generation of family ownership, and Vera still goes to work every day. (Courtesy of Vera Gildner.)

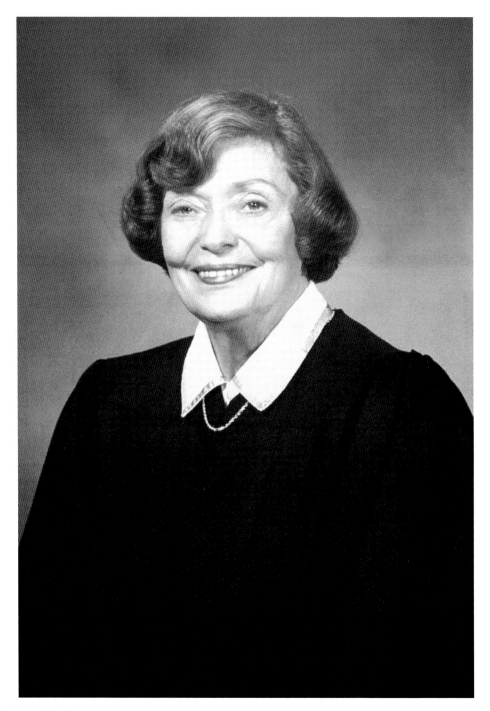

Joanna Neale
Neale came to Cheboygan in 1971 and soon began to practice law, becoming the first woman to do so in the community. She went on to become the first female probate judge and the first woman appointed to the board of Lake Superior State University. (Courtesy of the Historical Society of Cheboygan County Inc.)

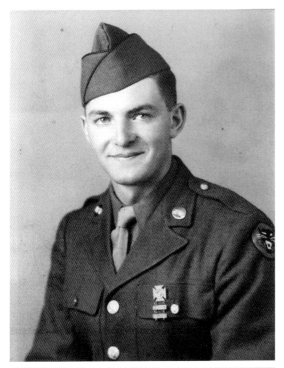

Ed Stempky

About two weeks after the D-Day invasion of Normandy on June 6, 1944, Stempky arrived in France as part of a unit in charge of operating six massive artillery guns. These guns were the only ones of their size in use by the Americans, and moving them from place to place was a laborious process. To avoid being seen by the Nazis, the guns were covered with camouflaged netting. Once, when this netting was thrown over a hot barrel, it caught on fire with 50 shells located immediately adjacent, equipped with quick detonating fuses. An officer ordered everyone to back away, but Stempky sprang into action and single handedly removed the burning net. He was promised a medal, but as the war dragged on he forgot about the assured honor.

Almost 70 years later, with his wife's persistence, Ed and Carol discovered that he had indeed been awarded a medal—the Bronze Star with V device for heroism. Strangely, he had never received it. But in December 2012, a box arrived in the mail, and he finally got to hold his well earned honor. Stempky was humble about the actions that earned him the medal, but what he did that day with instinctive heroism likely saved the lives of many men, as well as a vital piece of equipment needed for the Allied triumph. (Top, courtesy Ed Stempky; bottom, author's collection.)

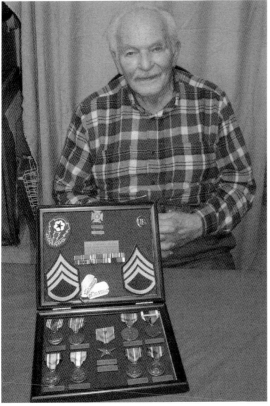

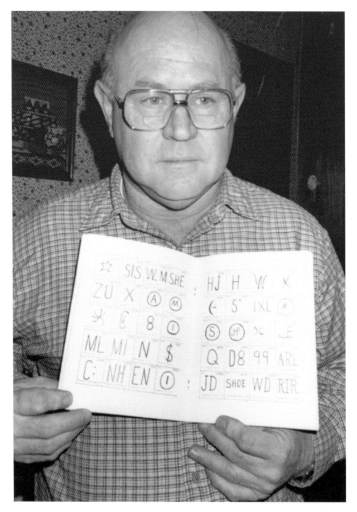

Ellis N. Olson

Among those who have preserved the history of the region, few can claim to have accomplished as much as Olson has. He became a teacher in rural Cheboygan County schools in 1965, and eventually Black River School, East Side, and the Junior High School. After extensive research, in 1972 he discovered the site of the John Campbell/Michael Dousman sawmill at nearby Mill Creek, which today is known as Historic Mill Creek Discovery Park. Additionally, he has written numerous publications on local history and penned dozens of articles about the region.

In 1968, Olson founded Cheboygan's first museum, the Cheboygan Area Free Museum and Historical Library. It was located in the basement of the former Carnegie Library building and contained artifacts from his own collection. The museum was transferred to the Historical Society of Cheboygan County, of which Olson was the first president.

Olson's pursuits were not just historical in nature. He served a term on city council, five terms as mayor, and sat on numerous boards, including the Opera House commission, planning commission, and recreation commission. As mayor, his accomplishments were many, including the construction of a new Lincoln Avenue Bridge, the renovation of the city hall and Opera House, new city street lighting, a new terminal and hangars at the city-county airport, a new wastewater treatment plant, and more.

A man who preserves history as well as makes it, Olson's impact on Cheboygan will be felt for generations to come. (From the *Cheboygan Centennial, 188–1989.*)

Patricia L. Watson
A familiar face for generations of Cheboyganites, Watson was an omnipresent figure at St. Mary's Church for over 40 years. She served the church in numerous capacities, including as a teacher's aide at Bishop Baraga School and as director of ministries. She also helped to provide assistance to area families in need, meeting with them one on one. In addition to her activities at the church, she was a volunteer for Habitat for Humanity, a member of the Cheboygan Area Ministerial Association, and was named Female Citizen of the Year in 2008. Full of energy and always on the go, Watson was a dedicated servant to the church, to Cheboygan, and to its people. (Both, author's collection.)

Roman Stempky.
Stempky has probably seen more people go through Cheboygan Area High School than any other person. Despite a disability, he worked diligently for 40 years in the cafeteria kitchen at the school, riding his bike to work and hardly ever missing a day (and if he did, it took two people to do his job). He also carried the American flag at the beginning of sporting events as the national anthem was played. A graduate of CHS himself, Stempky was an extremely dedicated fan of the Chiefs.

Not only a fan of local sports, Stempky loved the Detroit Tigers and went to a game each year. He enjoyed watching the games, meeting the players, and a yearly experience in the Tiger dugout. In the image below, he and longtime Tiger manager and Baseball Hall of Fame inductee Sparky Anderson meet and pose for a photograph. (Courtesy of Ed and Carol Stempky.)

James A. Taggart

The tradition of high school athletics runs deep in Cheboygan, and few people have made an impact on it like Taggart. An ever-present figure at high school sporting events, for over 25 years, he kept statistics for the Chiefs football team and was an announcer for basketball games as well. He was a dedicated supporter and volunteer for the DADS (Dedicated Athletes Deserve Support) Club and also designed the former Cheboygan Chiefs logo. Taggart also volunteered weekly with the Lord's Kitchen and was a former school board member. In 2012, a new entrance gate was constructed at the Western Avenue Field and dedicated in Taggart's honor. (Courtesy of Mary Taggart.)

Lyle McKinley

McKinley made a large impact on Cheboygan, not just through his professional work but also through his efforts to improve life for everyone in the community. He joined the staff of Citizens National Bank in 1953 and eventually became president in 1968. McKinley would continue to work at the bank for another 20 years while also being involved with the American Bankers Association and serving as president of the Michigan Bankers Association and as one of the original directors of the Northern Michigan School of Banking.

Locally, McKinley was on the board of Community Memorial Hospital and helped to secure over a million dollars in donations to facilitate the construction of a new wing for the facility. He was also a past Grand Knight of the local Knights of Columbus council and was active in the Kiwanis and Cheboygan Golf and Country Clubs. (Courtesy of Jerry Pond.)

Charles Plaunt

For four generations, getting from Cheboygan to nearby Bois Blanc Island in the summer has meant taking a Plaunt Transportation ferry. Charles Plaunt (pictured) took over a contract to deliver mail to the sparsely populated island in 1932. Aside from a brief interval around 1940, the Plaunts have hauled not only the mail, but also passengers, groceries, building supplies, and vehicles between Cheboygan and Bois Blanc ever since. After Charles died in 1937, his son Ray took over the family business, which has since been carried on to Ray's son Curt and Ray's grandsons Jason Plaunt and Ryan McLaren. (Courtesy of the Plaunt family.)

Plaunt Transportation

Above, at the company's 75th anniversary party in 2007, three generations of captains posed. From left to right are Jason Plaunt, Curt Plaunt, Ray Plaunt, Ryan McLaren, and Brent Sharpe. Plaunt Transportation has had five different ferries over its storied history: the *Adventure*, *Ada M.*, *Char-Leann II*, *Chee-Maun-Nes*, and *Kristen D.* Smaller vessels such as the *Chee-Maun-Nes* (below) could carry a few passengers, but today, the *Kristen D.* can carry many more passengers and their vehicles. As demand grew, barges were towed behind to accommodate additional vehicles or equipment. (Both, courtesy of the Plaunt family.)

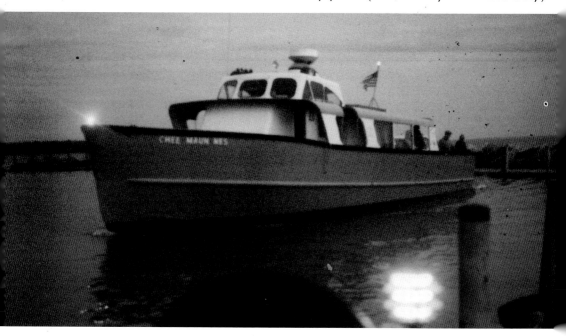

Fr. Paul Megge

After a long career in law enforcement, Megge (left) retired as undersheriff of Lapeer County, then served in that role in Tuscola County until 1994. He then answered a calling to serve the people in a different way—as a priest. Ordained for the Diocese of Gaylord in 1998, he served at St. Mary/St. Charles in Cheboygan for 12 years. Known for his jovial nature, warm presence, and compassion, he was also pastor when the new Bishop Baraga School was constructed. Megge is now retired once again, but can still be seen conducting liturgies throughout Northern Michigan. He is pictured here with Msgr. Dan Gallagher high above St. Peter's Square in Vatican City. (Author's collection.)

Billy Jewell

Growing up around music, from an early age, Jewell learned to appreciate how music moves its listeners. He learned to make his own music when his father taught him a few chords at about age 13, and by 17 he was playing professionally. He has not slowed down since, and for the last decade, Jewell has been a professional musician. Today, he plays throughout Northern Michigan, the state, and even in the Deep South. His band, Billy Jewell and His Bad Habits, has opened for many national acts and plays at Comerica Park on opening day of baseball season. Jewell's performances draw crowds throughout the year, and his music has become a soundtrack for the region. He is pictured here above his wife, Kris. (Courtesy of Billy Jewell.)

Brenda Archambo

Learning to appreciate the beauty and sanctity of the outdoors and wildlife at a very young age influenced Archambo's eventual career aspirations. She is a research consultant for the National Wildlife Federation and was instrumental in creating the Black Lake Sturgeon for Tomorrow chapter, of which she is president. Aiming to preserve this important animal for future generations, the organization has assisted the state with establishing responsible harvesting limits and preserving the sturgeon fishery.

Archambo's advocacy has taken her all the way to Washington, DC, where she testified in front of Congress on the importance of fishing to the Northern Michigan lifestyle. For Archambo, her work as a conservationist is about preparing a legacy of defending nature and sustainability, along with economic growth, now and into the future. (Courtesy of Brenda Archambo.)

BIBLIOGRAPHY

The following sources were among those consulted in the preparation of this work. They also serve as excellent resources to learn more about the history of the Cheboygan area and its people.

Atwood, Lloyd M. "Cheboygan as a Nineteenth Century Lumber Area." Master's thesis, Wayne University, 1947.

Cheboygan Centennial: In the Spirit of Manitawauba. Petoskey, MI: Review Printing Company, 1971.

Cheboygan, Up-to-Date. Cheboygan, MI: Cheboygan Democrat, 1898.

Friday, Matthew J. Among the Sturdy Pioneers: The Birth of the Cheboygan Area as a Lumbering Community, 1778–1935. Victoria, BC, Canada: Trafford Publishing, 2006.

Gibson, D.L. Michigan Technical Bulletin 193. "Socio-Economic Evolution in a Timbered Area in Northern Michigan." East Lansing, MI: Michigan State College, 1944.

Insurance Maps of Cheboygan, Michigan. Sanborn-Perris Map Co. Ltd, 1884–1915.

Olds, Millard David. Collection of personal and business papers. Clarke Historical Library, Central Michigan University, Mt. Pleasant, MI.

Olson, Ellis. Cheboygan Centennial 1889–1989. Cheboygan, MI: City of Cheboygan, 1989.

————. Cheboygan Historical Sketches. Cheboygan, MI: Cheboygan Area Chamber of Commerce, 1976, 1979.

Portrait and Biographical Record of Northern Michigan. Chicago, IL: Record Publishing Company, 1895.

Powers, Perry F. A History of Northern Michigan and its People. Chicago, IL: Lewis Publishing Co., 1912.

The Traverse Region, Historical and Descriptive, Illustrated. Chicago, IL: H.R. Page and Co., 1884.

Titus, Harold. "Cheboygan's Chin is Up." Saturday Evening Post, July 6, 1946.

Ware, Rev. W.H. The Centennial History of Cheboygan County and Village. Cheboygan, MI: Northern Tribune Printing, 1876.

INDEX

AN IMPRINT OF ARCADIA PUBLISHING

Find more books like this at
www.legendarylocals.com

Discover more local and regional history books at
www.arcadiapublishing.com

Consistent with our mission to preserve history on a local level, this book was printed in South Carolina on American-made paper and manufactured entirely in the United States. Products carrying the accredited Forest Stewardship Council (FSC) label are printed on 100 percent FSC-certified paper.

MADE IN THE USA